BECOMING ANDY WARHOL

by **NICK BERTOZZI**

illustrated by **PIERCE HARGAN**

ABRAMS COMICARTS ● NEW YORK

At the dawn of the 1960s, commercial illustrator Andy Warhol wanted desperately to become a famous painter. He worked tirelessly to break into the flourishing New York City gallery scene, but he couldn't quite seem to rise above his misfit status . . . until he began to push the limits of everyone's imaginations, including his own.

After numerous gallery failures, Warhol finally scored a commission for the 1964 World's Fair—his only work of public art. His controversial mural of the *Thirteen Most Wanted Men* provoked a powerful response from urban planner Robert Moses, architect Philip Johnson, and New York Governor Nelson Rockefeller—igniting a firestorm that ultimately forced Warhol to make a choice that would either make or break his career.

By stubborn force of personality and sheer burgeoning talent, Warhol went up against the creative establishment and emerged to become one of the most significant and influential artists of the 20th century. This is the story of Warhol's path to that turning point, vividly reconstructed by *New York Times*-bestselling author Nick Bertozzi and breakout artist Pierce Hargan.

The World's Fair was out in Flushing Meadow . . . with my mural of the *Thirteen Most Wanted Men* on the outside of the building that Philip Johnson designed. Philip gave me the assignment, but because of some political thing I never understood, the officials had it whitewashed out. A bunch of us went to Flushing Meadow to have a look at it, but by the time we got there you could only see the images faintly coming through the paint they'd just put over them.

In one way I was glad the mural was gone: now I wouldn't have to feel responsible if one of the criminals ever got turned in to the FBI because someone had recognized him from my pictures.

—ANDY WARHOL
from his memoir, *Popism: The Warhol '60s*

PREFACE

I would have been the perfect young person for Andy Warhol to use: slightly broken, deeply gullible, and desperate to please. He would have chewed me up and spit me out, just as he did so many others over the course of his career. That Warhol—the one who was shot point-blank by a hanger-on, the artist who immortalized everyday objects with his depictions of Campbell's soup cans, who signed printed portraits of the wealthy and the famous that were created in his Factory—sits immovable at the foundation of glossy twenty-first-century pop culture. If that isn't obvious to you, turn on the television, Andy's favorite pastime, and witness the celebrity culture Warhol personified. But this book is not about the world-famous Andy Warhol; it's about the moment just before his fame, when he longed to get out of the illustration racket and be treated like a heavyweight. This book is his origin story, you might say.

Becoming Andy Warhol was originally titled *America's Thirteen Most Wanted Men*. A twenty-foot-by-twenty-foot mural titled *Thirteen Most Wanted Men* was commissioned by the architect Philip Johnson, to be hung on the side of the Johnson-designed New York State Pavilion at the 1964 World's Fair. When the installation caused a political uproar, Warhol was forced to make a choice. It was a choice deeply influenced by the young, non-mainstream crowd he met through his assistants Gerard Malanga and Billy Name; by his decision to leave the small Stable Gallery for the prestigious Castelli Gallery; and in defiance of the attitudes of his mother, who lived with him. It was the turning point of his transformation from the child of working-class immigrants into an artist with an American vision.

Becoming Andy Warhol is not meant to be read as a scholarly work. In writing this graphic novel, I followed the historical record as best I could, but I compressed some events and added or subtracted people from scenes to create a story that would serve as an engaging and thoughtful guide to the experiences that became his art. This is my interpretation of Warhol, pulled from biographies, documentaries, and interviews as well as his work. The sources are listed in the back of the book.

Now, allow me to tell you about my collaborator, Pierce Hargan. He's young, he's smart, he's from California, and he has a cartooning voice that is unique in the best manner possible. Look at the cover again (front and back). Look at the backgrounds of the interior art—and marvel, as I do, at the pitch-perfect depiction of 1960s New York City. But also look at his people—that's important. Pierce gets the poses, the facial nuances, and the hands exactly right. As a cartoonist myself, I found it difficult to let someone else draw my script, but I'm very glad it was Pierce. It's obvious that he's just beginning an amazing career.

My college art history classes consisted of surveys of painters and sculptors: their works, the dates they created them, and the movements they fell within. In this mode of presentation, artists become mythical legends, gracing mortals with their Olympian visions. But I wanted to know them as people, to know where they lived, to understand the experiences of their lives that pushed them to make their work, and to find out why it mattered where their work was displayed. That was also my objective for the book you hold in your hands—to make this creative and defining period of Warhol's life stand on its own, and serve as a very different kind of introduction to the career of this remarkable artist. One that has extended far beyond "fifteen minutes."

NICK BERTOZZI
Ridgewood, New York

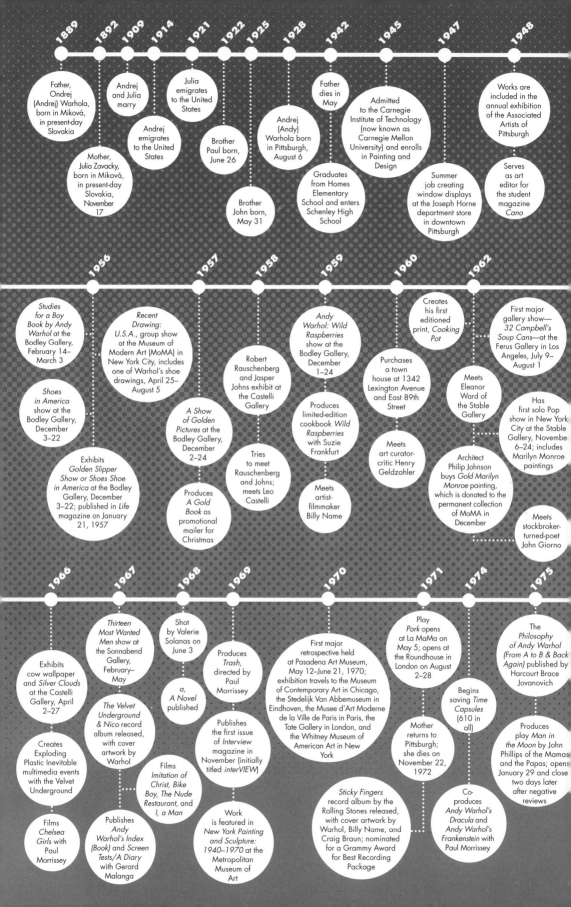

1889
Father, Ondrej (Andrej) Warhola, born in Miková, in present-day Slovakia

Mother, Julia Zavacky, born in Miková, in present-day Slovakia, November 17

1892
Andrej and Julia marry

1909
Andrej emigrates to the United States

1914
Julia emigrates to the United States

1921
Brother Paul born, June 26

1922
Brother John born, May 31

1925
Andrej (Andy) Warhola born in Pittsburgh, August 6

1928
Graduates from Homes Elementary School and enters Schenley High School

1942
Father dies in May

1945
Admitted to the Carnegie Institute of Technology (now known as Carnegie Mellon University) and enrolls in Painting and Design

1947
Summer job creating window displays at the Joseph Horne department store in downtown Pittsburgh

1948
Works are included in the annual exhibition of the Associated Artists of Pittsburgh

Serves as art editor for the student magazine *Cano*

1956
Studies for a Boy Book by Andy Warhol at the Bodley Gallery, February 14–March 3

Shoes in America show at the Bodley Gallery, December 3–22

Exhibits *Golden Slipper Show or Shoes Shoe in America* at the Bodley Gallery, December 3–22; published in *Life* magazine on January 21, 1957

1957
Recent Drawing: U.S.A., group show at the Museum of Modern Art (MoMA) in New York City, includes one of Warhol's shoe drawings, April 25–August 5

A Show of Golden Pictures at the Bodley Gallery, December 2–24

Produces *A Gold Book* as promotional mailer for Christmas

1958
Robert Rauschenberg and Jasper Johns exhibit at the Castelli Gallery

Tries to meet Rauschenberg and Johns; meets Leo Castelli

1959
Andy Warhol: Wild Raspberries show at the Bodley Gallery, December 1–24

Produces limited-edition cookbook *Wild Raspberries* with Suzie Frankfurt

Meets artist-filmmaker Billy Name

1960
Creates his first editioned print, *Cooking Pot*

Purchases a town house at 1342 Lexington Avenue and East 89th Street

Meets art curator-critic Henry Geldzahler

1962
First major gallery show—*32 Campbell's Soup Cans*—at the Ferus Gallery in Los Angeles, July 9–August 1

Meets Eleanor Ward of the Stable Gallery

Has first solo Pop show in New York City at the Stable Gallery, Novembe 6–24; includes Marilyn Monroe paintings

Architect Philip Johnson buys *Gold Marilyn Monroe* painting, which is donated to the permanent collection of MoMA in December

Meets stockbroker-turned-poet John Giorno

1966
Exhibits cow wallpaper and *Silver Clouds* at the Castelli Gallery, April 2–27

Creates Exploding Plastic Inevitable multimedia events with the Velvet Underground

Films *Chelsea Girls* with Paul Morrissey

1967
Thirteen Most Wanted Men show at the Sonnabend Gallery, February–May

The Velvet Underground & Nico record album released, with cover artwork by Warhol

Films *Imitation of Christ*, *Bike Boy*, *The Nude Restaurant*, and *I, a Man*

Publishes *Andy Warhol's Index (Book)* and *Screen Tests/A Diary* with Gerard Malanga

1968
Shot by Valerie Solanas on June 3

a, A Novel published

1969
Produces *Trash*, directed by Paul Morrissey

Publishes the first issue of *Interview* magazine in November (initially titled *interVIEW*)

Work is featured in *New York Painting and Sculpture: 1940–1970* at the Metropolitan Museum of Art

1970
First major retrospective held at Pasadena Art Museum, May 12–June 21, 1970; exhibition travels to the Museum of Contemporary Art in Chicago, the Stedelijk Van Abbemuseum in Eindhoven, the Musee d'Art Moderne de la Ville de Paris in Paris, the Tate Gallery in London, and the Whitney Museum of American Art in New York

Sticky Fingers record album by the Rolling Stones released, with cover artwork by Warhol, Billy Name, and Craig Braun; nominated for a Grammy Award for Best Recording Package

1971
Play *Pork* opens at La MaMa on May 5; opens at the Roundhouse in London on August 2–28

Mother returns to Pittsburgh; she dies on November 22, 1972

1974
Begins saving *Time Capsules* (610 in all)

Co-produces *Andy Warhol's Dracula* and *Andy Warhol's Frankenstein* with Paul Morrissey

1975
The Philosophy of Andy Warhol (From A to B & Back Again) published by Harcourt Brace Jovanovich

Produces play *Man in the Moon* by John Phillips of the Mamas and the Papas; opens January 29 and close two days later after negative reviews

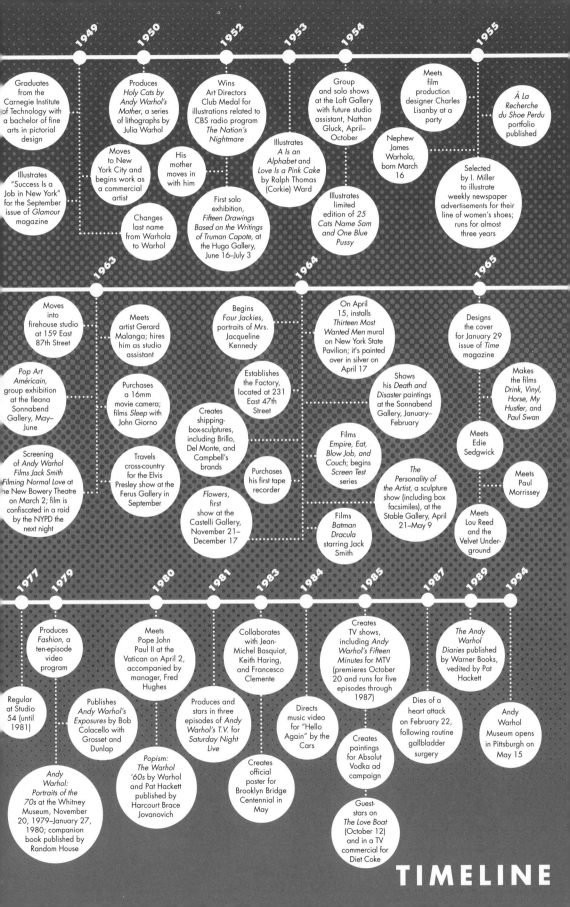

1949

Graduates from the Carnegie Institute of Technology with a bachelor of fine arts in pictorial design

Illustrates "Success Is a Job in New York" for the September issue of *Glamour* magazine

1950

Produces *Holy Cats by Andy Warhol's Mother*, a series of lithographs by Julia Warhol

Moves to New York City and begins work as a commercial artist

Changes last name from Warhola to Warhol

1952

Wins Art Directors Club Medal for illustrations related to CBS radio program *The Nation's Nightmare*

His mother moves in with him

First solo exhibition, *Fifteen Drawings Based on the Writings of Truman Capote*, at the Hugo Gallery, June 16–July 3

1953

Illustrates *A Is an Alphabet* and *Love Is a Pink Cake* by Ralph Thomas (Corkie) Ward

1954

Group and solo shows at the Loft Gallery with future studio assistant, Nathan Gluck, April–October

Illustrates limited edition of *25 Cats Name Sam and One Blue Pussy*

1955

Meets film production designer Charles Lisanby at a party

Nephew James Warhola, born March 16

À La Recherche du Shoe Perdu portfolio published

Selected by I. Miller to illustrate weekly newspaper advertisements for their line of women's shoes; runs for almost three years

1963

Moves into firehouse studio at 159 East 87th Street

Pop Art Américain, group exhibition at the Ileana Sonnabend Gallery, May–June

Screening of *Andy Warhol Films Jack Smith Filming Normal Love* at the New Bowery Theatre on March 2; film is confiscated in a raid by the NYPD the next night

Meets artist Gerard Malanga; hires him as studio assistant

Purchases a 16mm movie camera; films *Sleep* with John Giorno

Travels cross-country for the Elvis Presley show at the Ferus Gallery in September

1964

Begins *Four Jackies*, portraits of Mrs. Jacqueline Kennedy

Establishes the Factory, located at 231 East 47th Street

Creates shipping-box-sculptures, including Brillo, Del Monte, and Campbell's brands

Purchases his first tape recorder

Flowers, first show at the Castelli Gallery, November 21–December 17

On April 15, installs *Thirteen Most Wanted Men* mural on New York State Pavilion; it's painted over in silver on April 17

Films *Empire, Eat, Blow Job, and Couch*; begins *Screen Test* series

Films *Batman Dracula* starring Jack Smith

Shows his *Death and Disaster* paintings at the Sonnabend Gallery, January–February

The Personality of the Artist, a sculpture show (including box facsimiles), at the Stable Gallery, April 21–May 9

1965

Designs the cover for January 29 issue of *Time* magazine

Makes the films *Drink, Vinyl, Horse, My Hustler*, and *Paul Swan*

Meets Edie Sedgwick

Meets Paul Morrissey

Meets Lou Reed and the Velvet Underground

1977

Regular at Studio 54 (until 1981)

1979

Produces *Fashion*, a ten-episode video program

Publishes *Andy Warhol's Exposures* by Bob Colacello with Grosset and Dunlap

Andy Warhol: Portraits of the 70s at the Whitney Museum, November 20, 1979–January 27, 1980; companion book published by Random House

1980

Meets Pope John Paul II at the Vatican on April 2, accompanied by manager, Fred Hughes

Popism: The Warhol '60s by Warhol and Pat Hackett published by Harcourt Brace Jovanovich

1981

Produces and stars in three episodes of *Andy Warhol's T.V.* for *Saturday Night Live*

1983

Collaborates with Jean-Michel Basquiat, Keith Haring, and Francesco Clemente

Creates official poster for Brooklyn Bridge Centennial in May

1984

Directs music video for "Hello Again" by the Cars

1985

Creates TV shows, including *Andy Warhol's Fifteen Minutes* for MTV (premieres October 20 and runs for five episodes through 1987)

Creates paintings for Absolut Vodka ad campaign

Guest-stars on *The Love Boat* (October 12) and in a TV commercial for Diet Coke

1987

Dies of a heart attack on February 22, following routine gallbladder surgery

1989

The Andy Warhol Diaries published by Warner Books, vedited by Pat Hackett

1994

Andy Warhol Museum opens in Pittsburgh on May 15

TIMELINE

FEATURING

LEO CASTELLI

HENRY GELDZAHLER

JOHN GIORNO

NATHAN GLUCK

JASPER JOHNS

PHILIP JOHNSON

CHARLES LISANBY

GERARD MALANGA

TAYLOR MEAD

BILLY NAME

ROBERT RAUSCHENBERG

ELEANOR WARD

JACK SMITH

ANDY WARHOL

JULIA WARHOLA

CHAPTER ONE

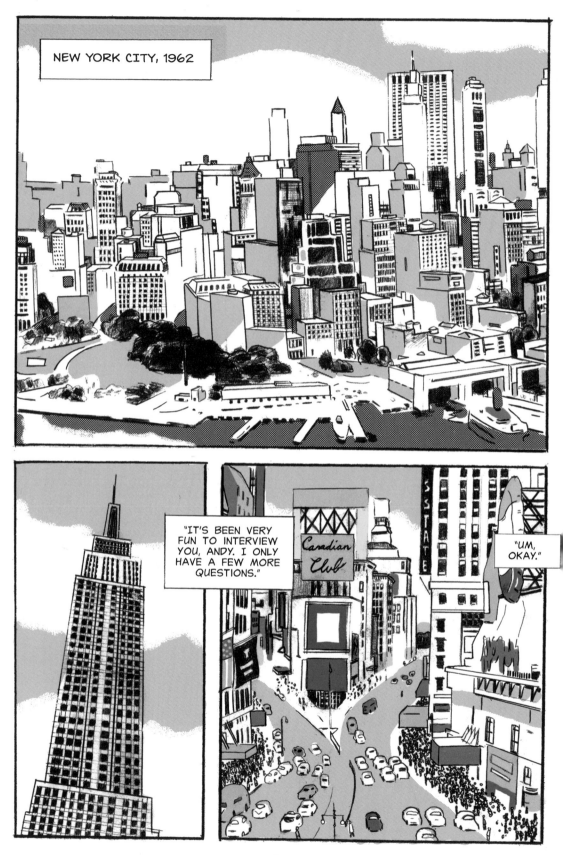

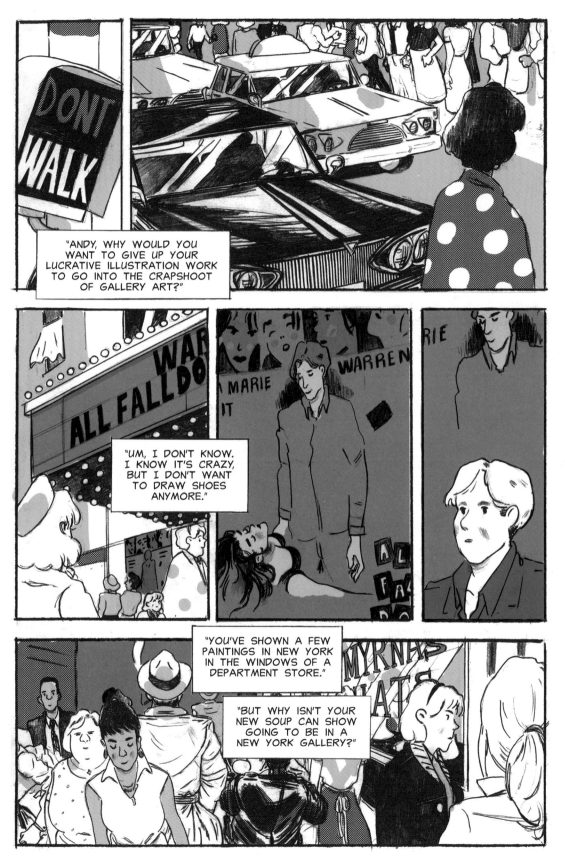

3

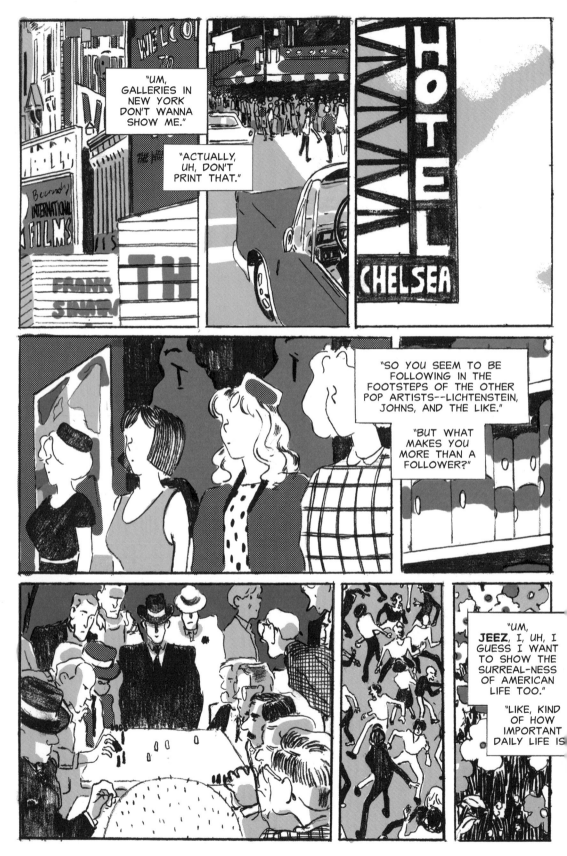

"UM, GALLERIES IN NEW YORK DON'T WANNA SHOW ME."

"ACTUALLY, UH, DON'T PRINT THAT."

"SO YOU SEEM TO BE FOLLOWING IN THE FOOTSTEPS OF THE OTHER POP ARTISTS--LICHTENSTEIN, JOHNS, AND THE LIKE."

"BUT WHAT MAKES YOU MORE THAN A FOLLOWER?"

"UM, **JEEZ**, I, UH, I GUESS I WANT TO SHOW THE SURREAL-NESS OF AMERICAN LIFE TOO."

"LIKE, KIND OF HOW IMPORTANT DAILY LIFE IS

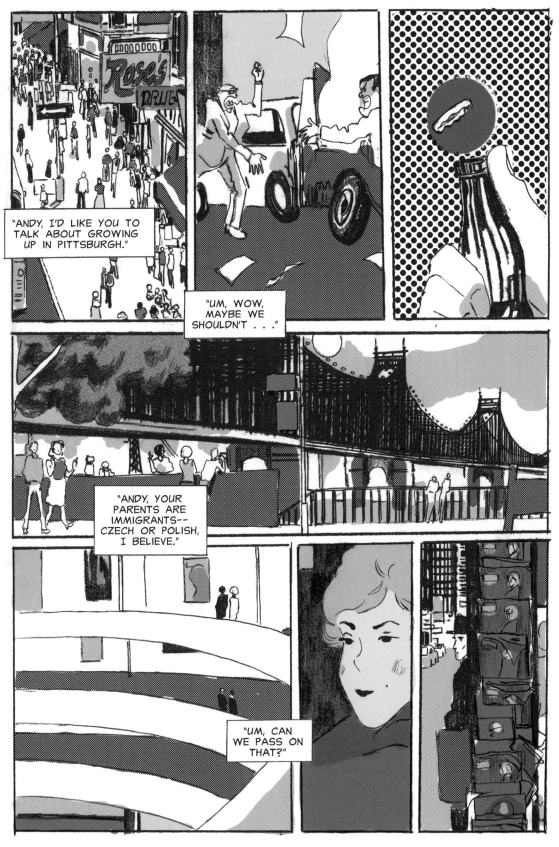

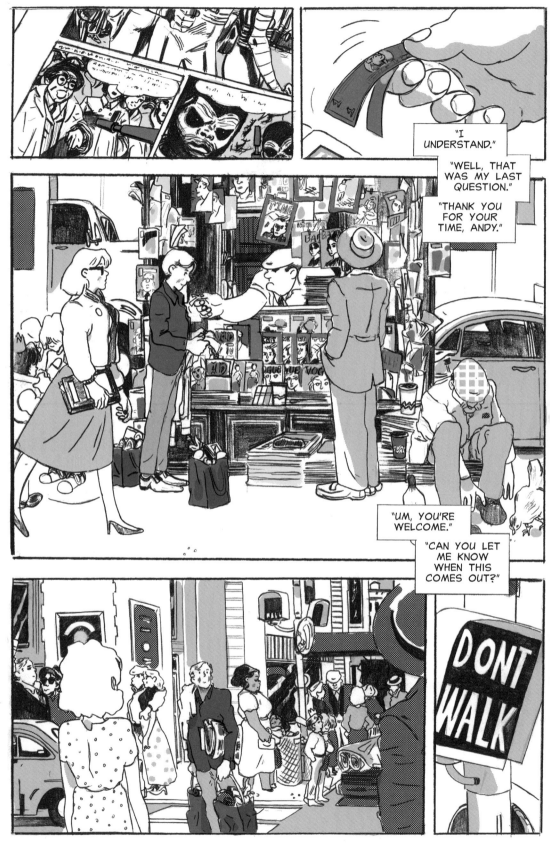

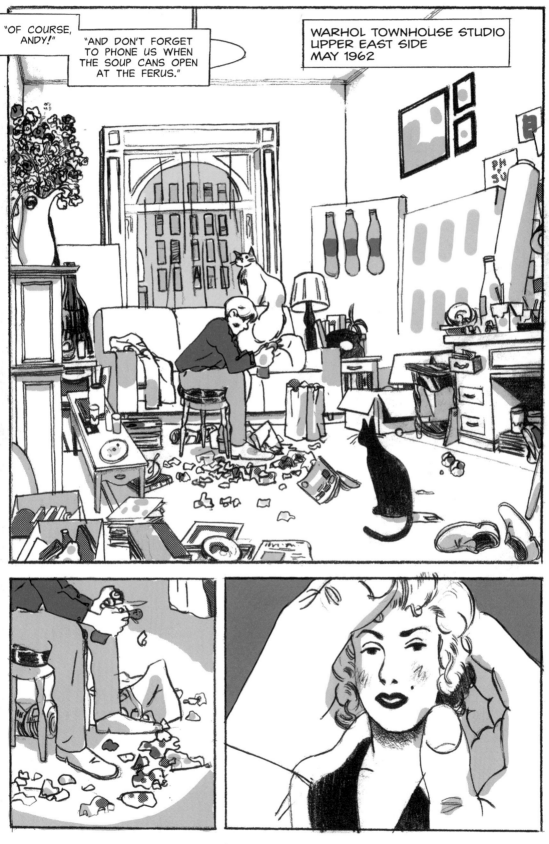

CHAPTER TWO

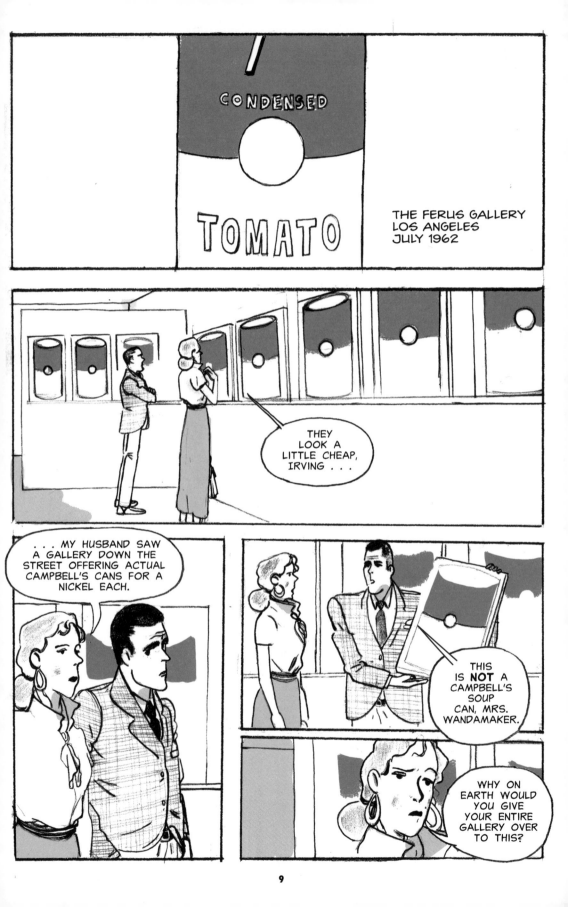

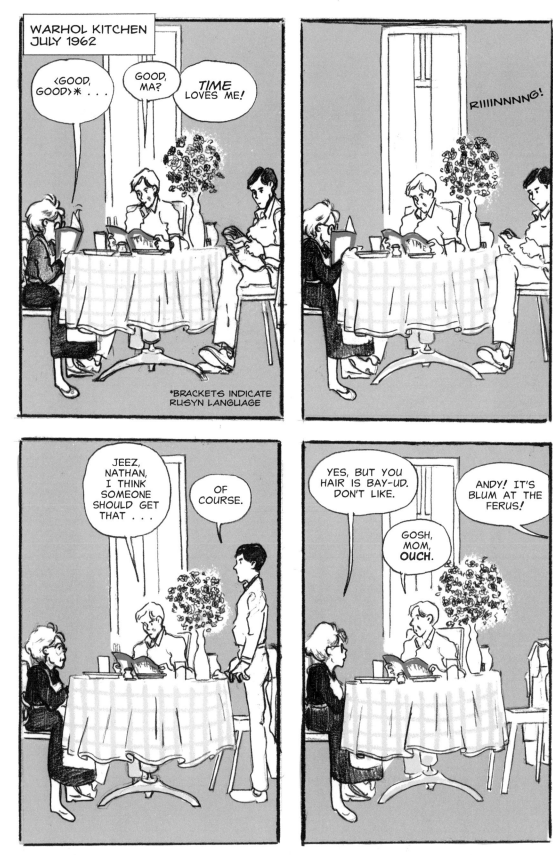

10

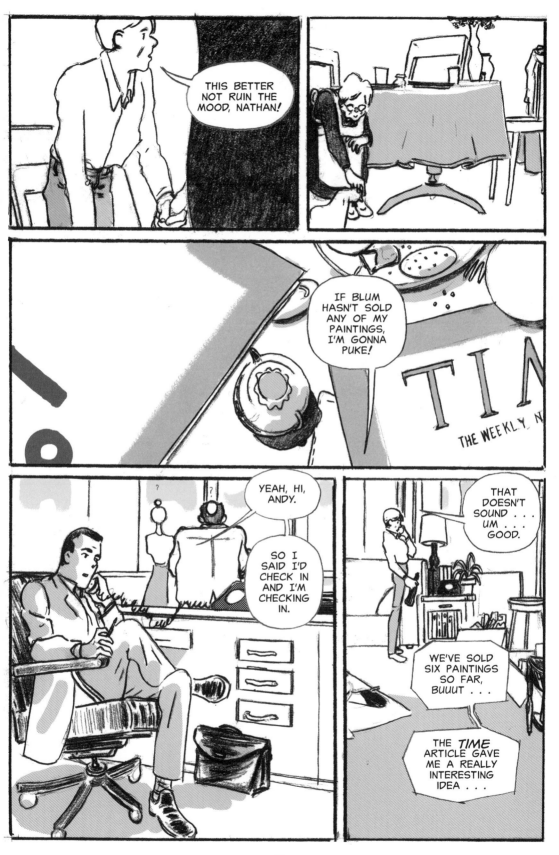

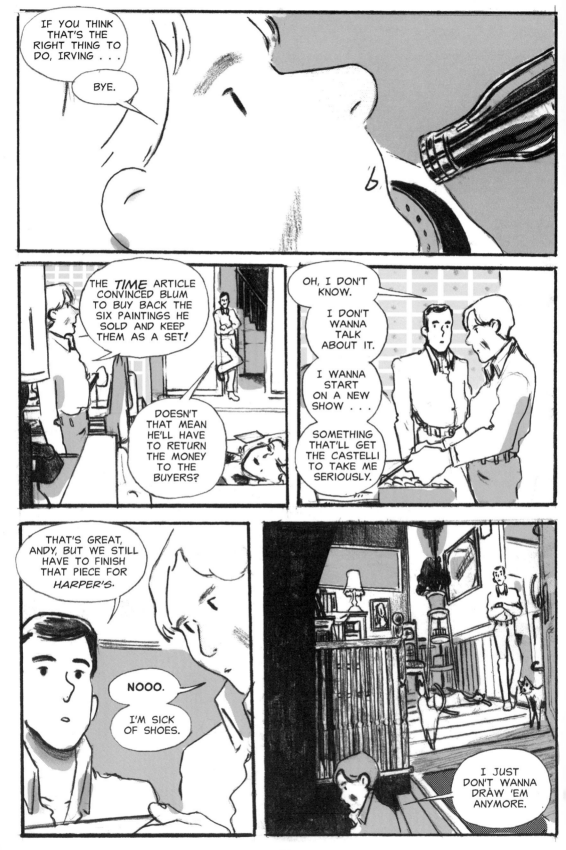

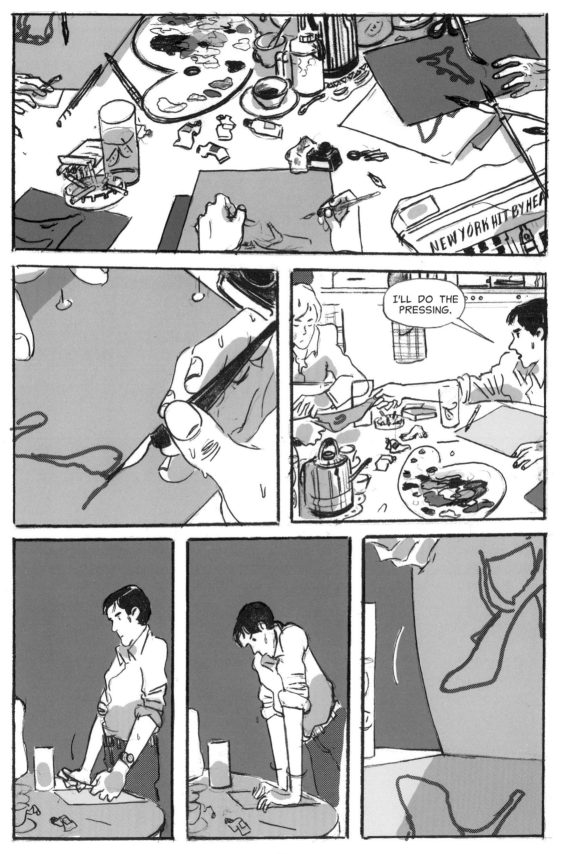

13

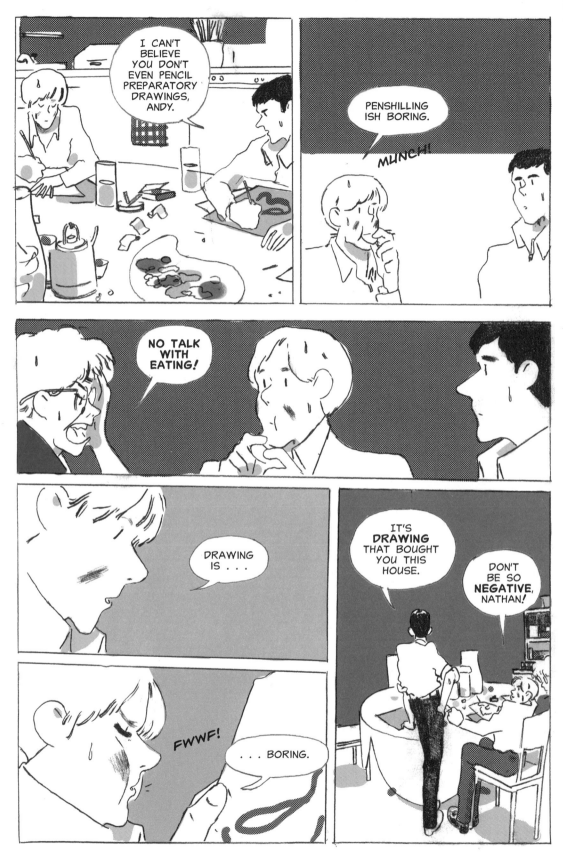

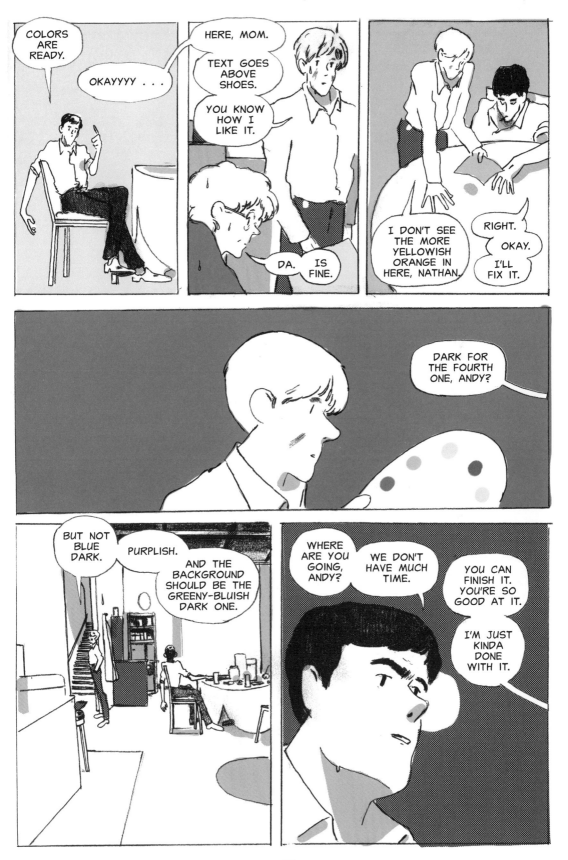

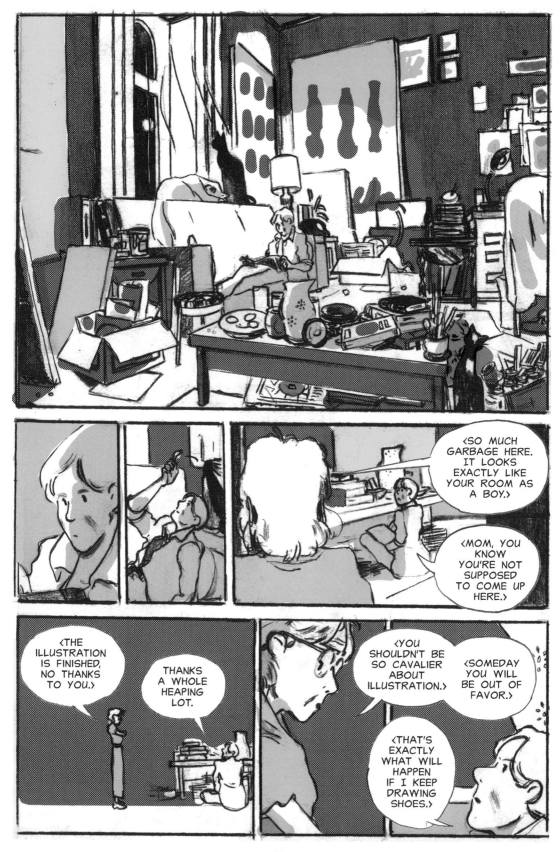

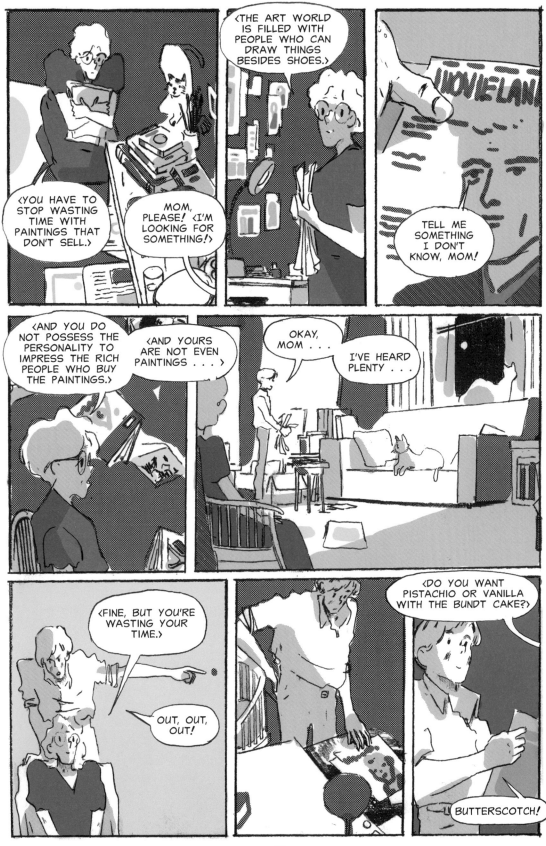

CHAPTER THREE

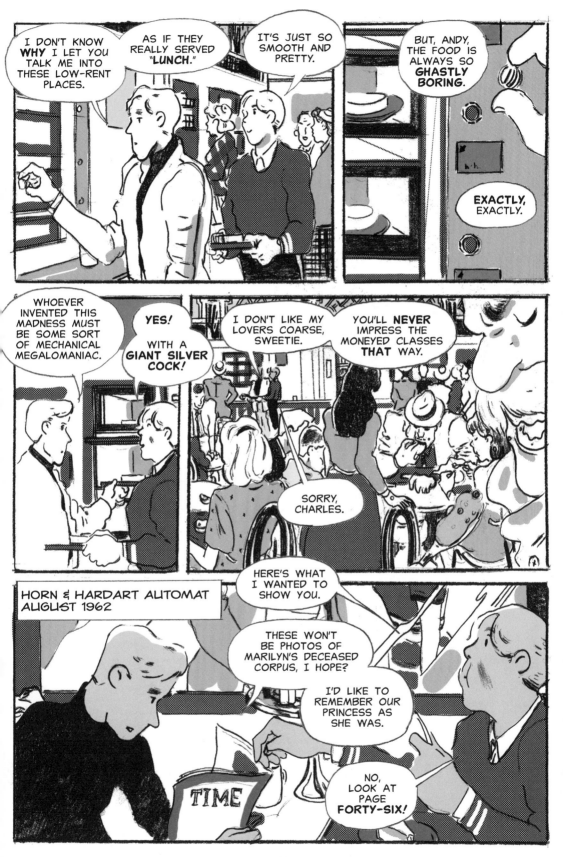

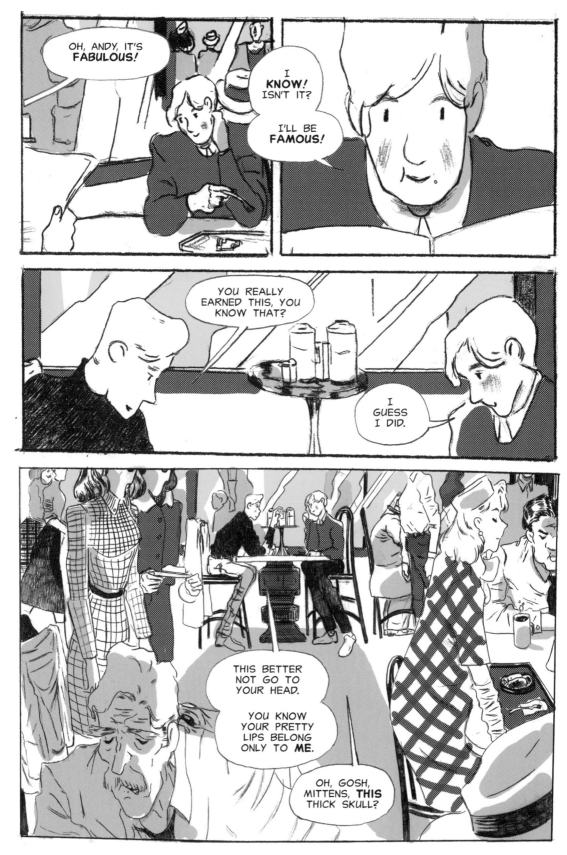

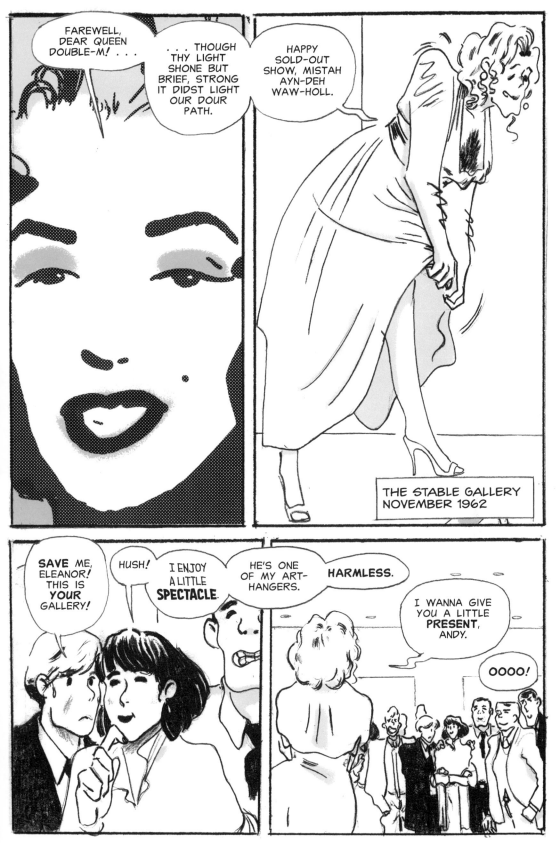

FAREWELL, DEAR QUEEN DOUBLE-M! . . .

. . . THOUGH THY LIGHT SHONE BUT BRIEF, STRONG IT DIDST LIGHT OUR DOUR PATH.

HAPPY SOLD-OUT SHOW, MISTAH AYN-DEH WAW-HOLL.

THE STABLE GALLERY NOVEMBER 1962

SAVE ME, ELEANOR! THIS IS YOUR GALLERY!

HUSH!

I ENJOY A LITTLE SPECTACLE.

HE'S ONE OF MY ART-HANGERS.

HARMLESS.

I WANNA GIVE YOU A LITTLE PRESENT, ANDY.

OOOO!

21

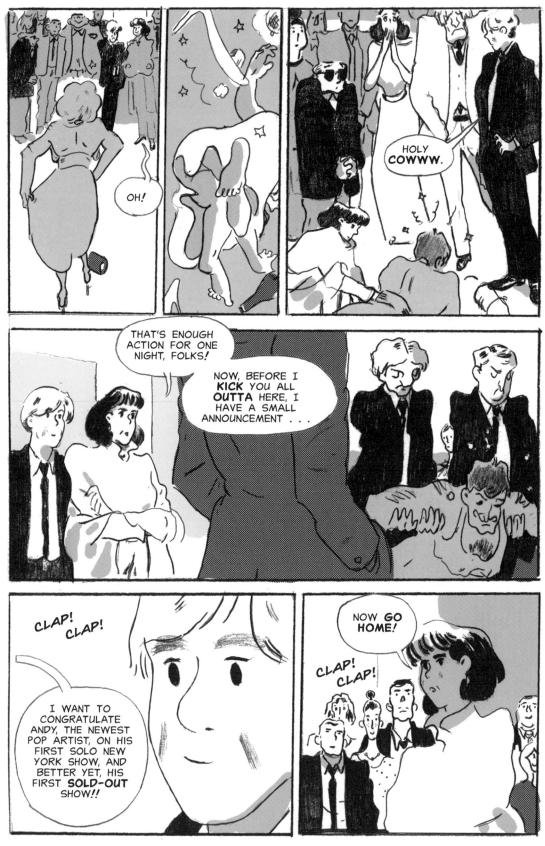

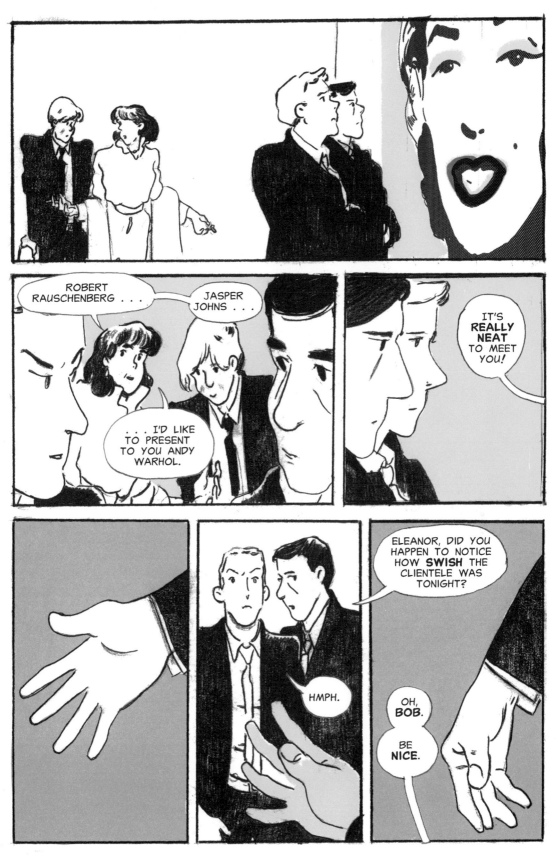

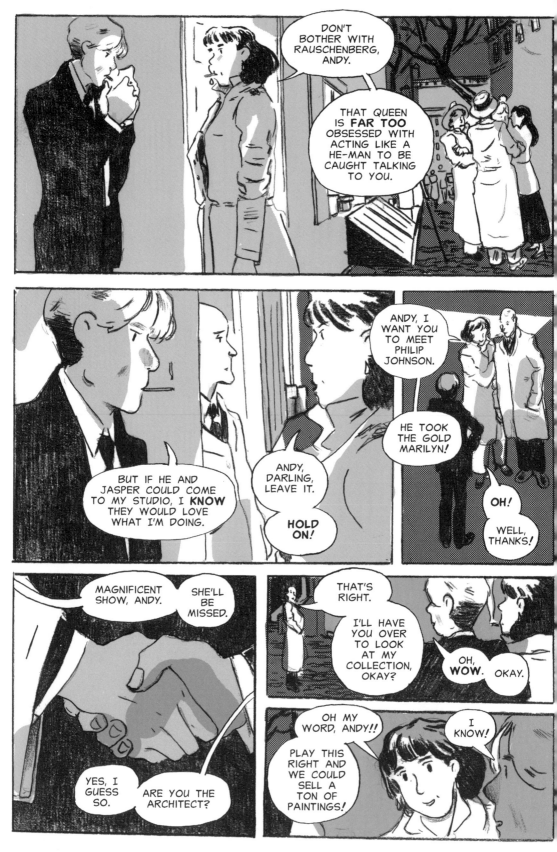

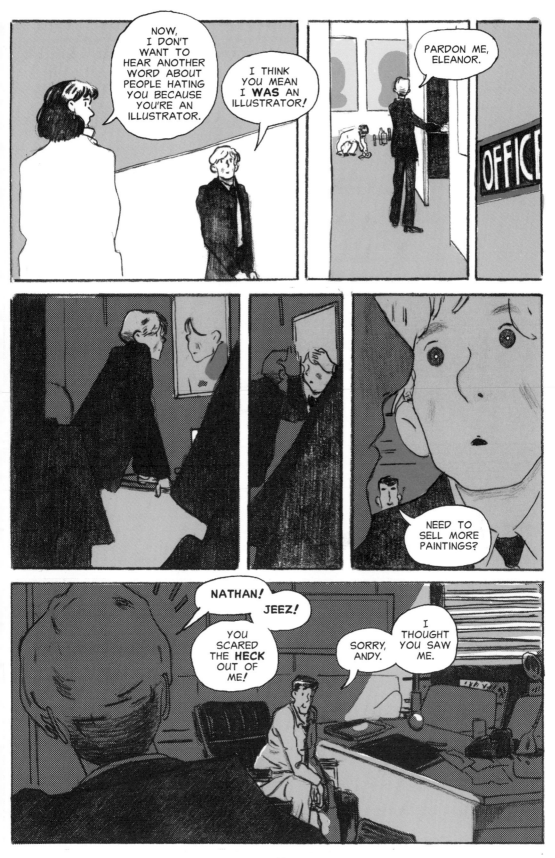

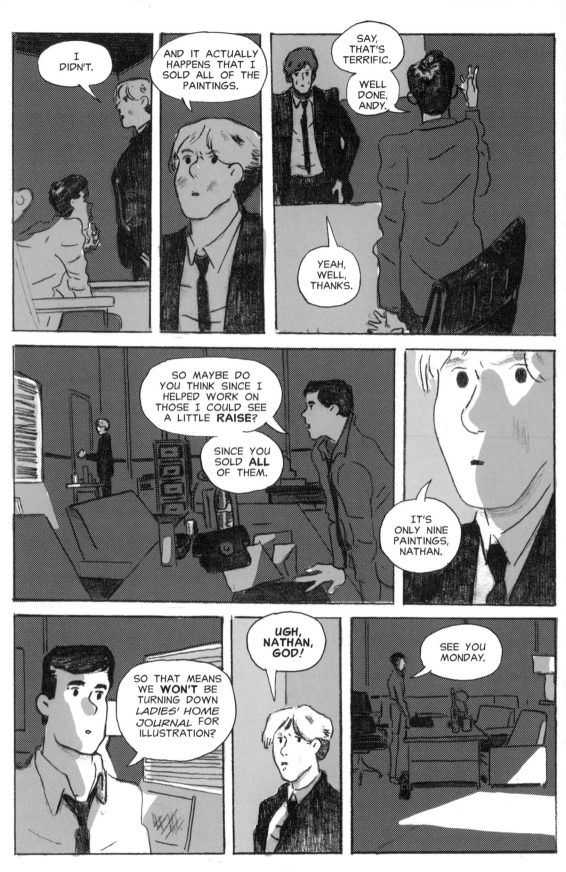

CHAPTER FOUR

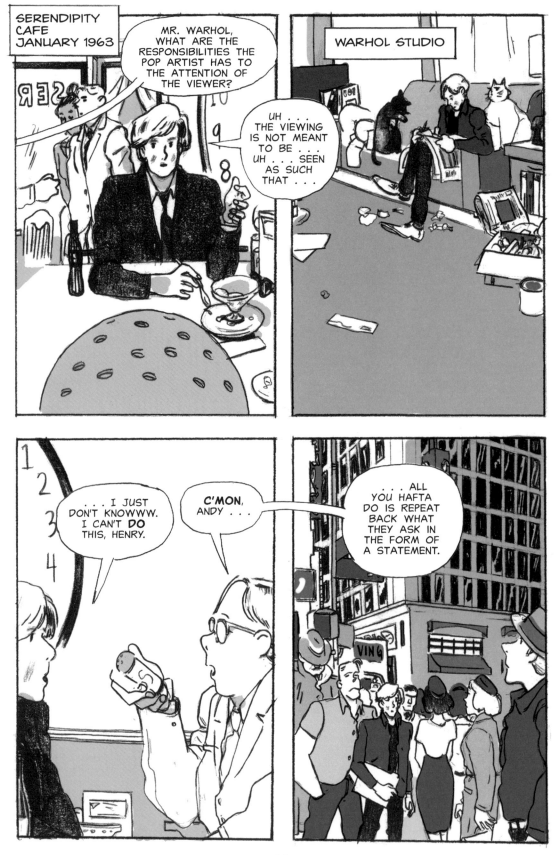

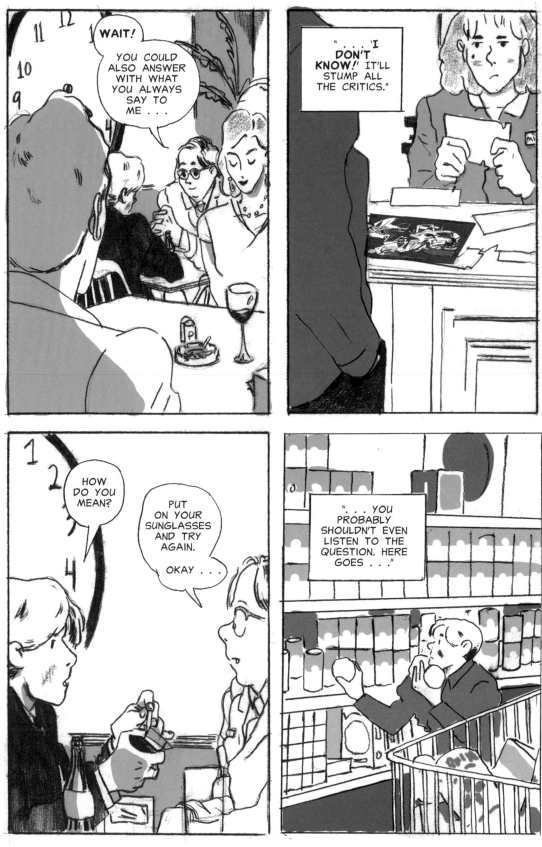

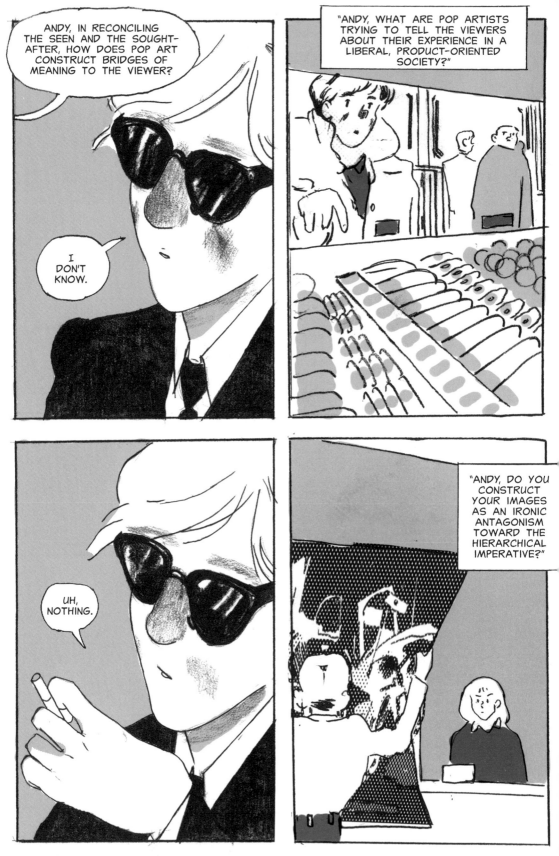

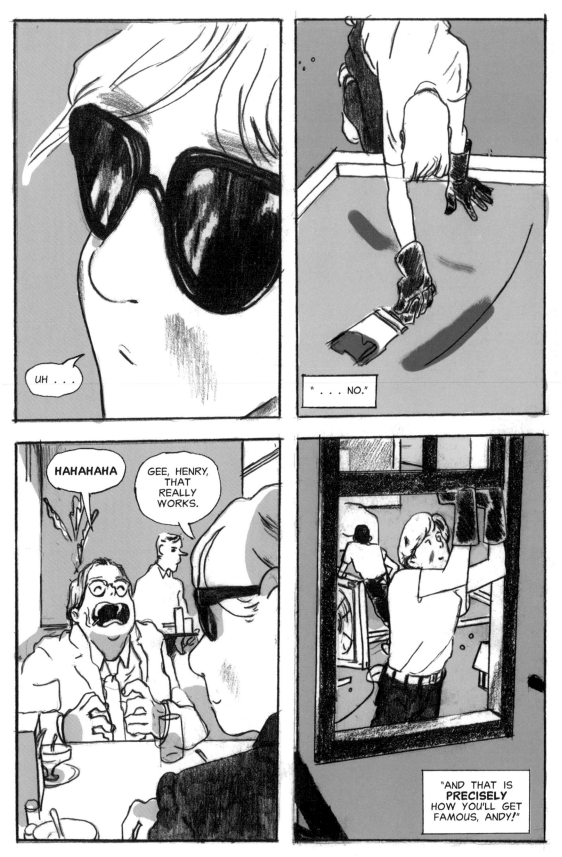

UH . . .

" . . . NO."

HAHAHAHA

GEE, HENRY, THAT REALLY WORKS.

"AND THAT IS **PRECISELY** HOW YOU'LL GET FAMOUS, ANDY*!*"

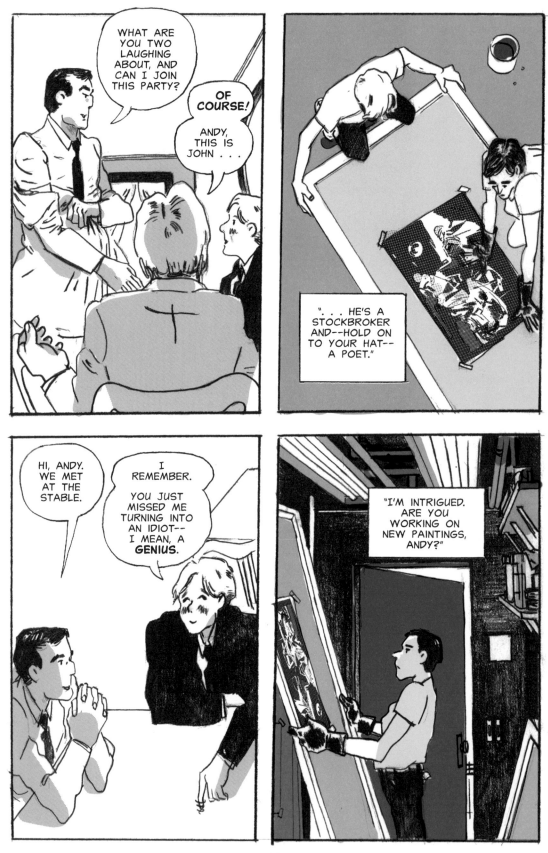

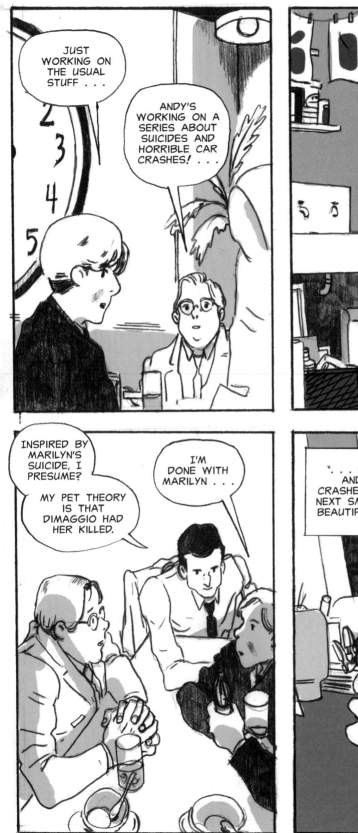

JUST WORKING ON THE USUAL STUFF . . .

ANDY'S WORKING ON A SERIES ABOUT SUICIDES AND HORRIBLE CAR CRASHES! . . .

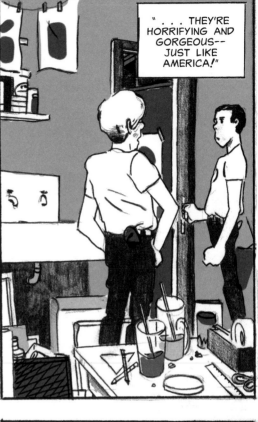

" . . . THEY'RE HORRIFYING AND GORGEOUS-- JUST LIKE AMERICA!"

INSPIRED BY MARILYN'S SUICIDE, I PRESUME?

MY PET THEORY IS THAT DIMAGGIO HAD HER KILLED.

I'M DONE WITH MARILYN . . .

" . . . SUICIDES AND CAR CRASHES ARE MY NEXT SMASHED-UP BEAUTIFUL THING."

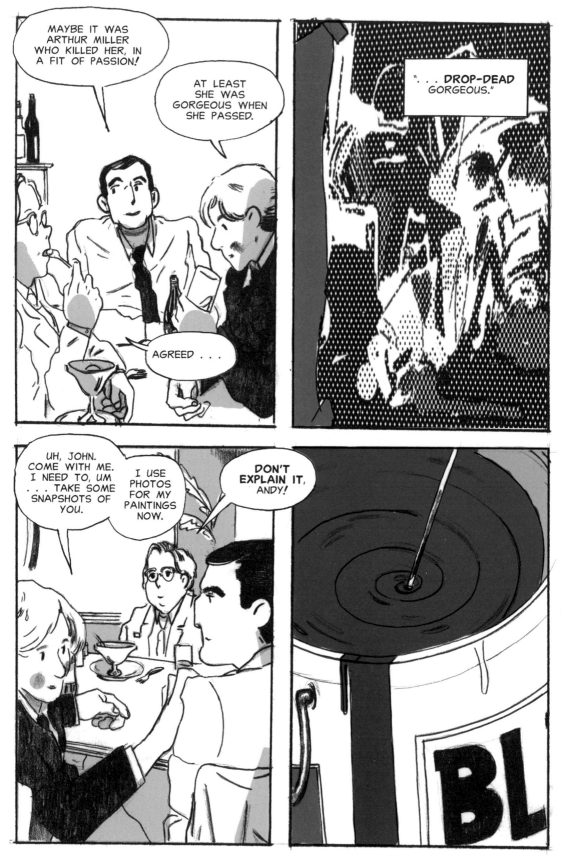

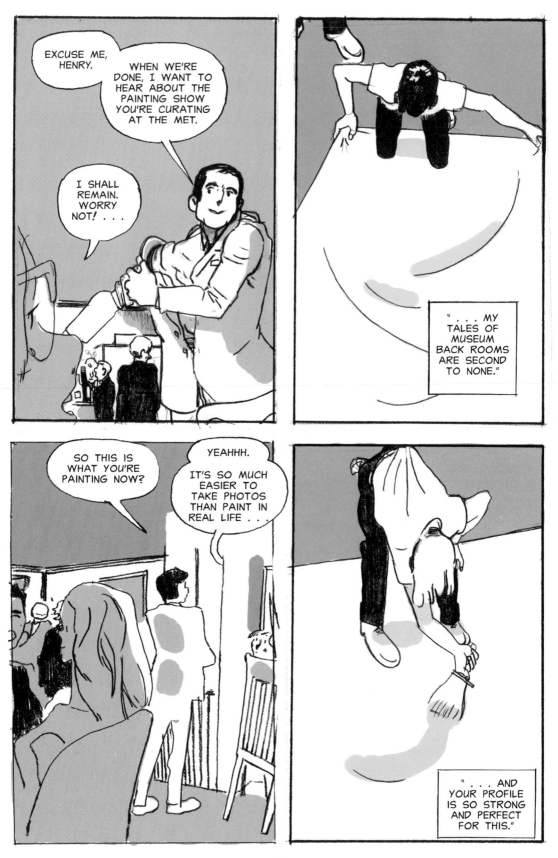

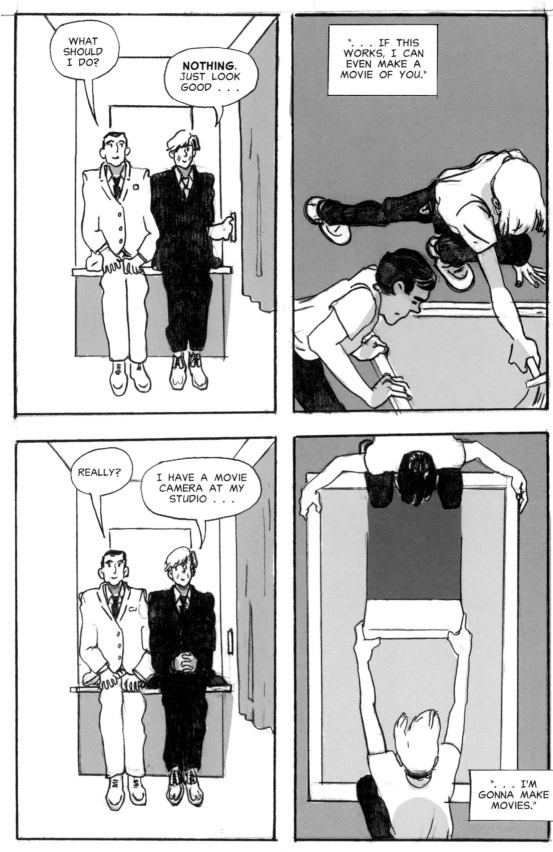

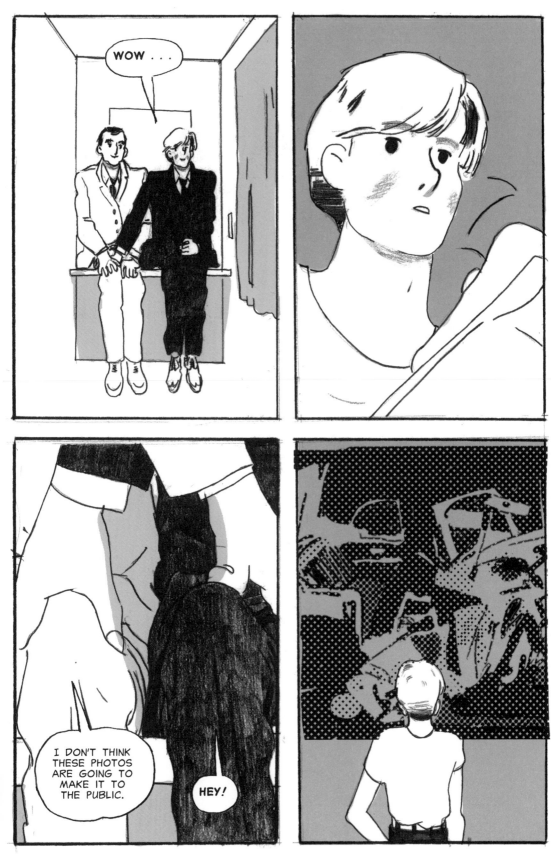

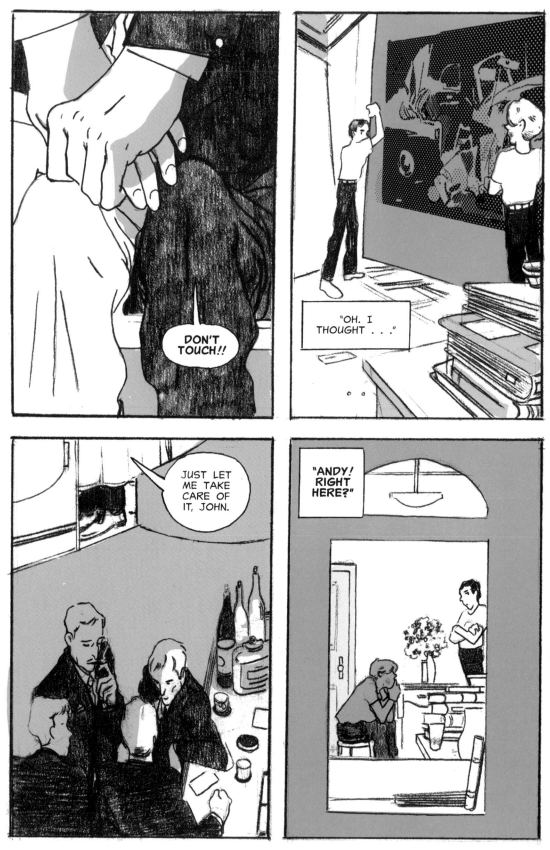

CHAPTER FIVE

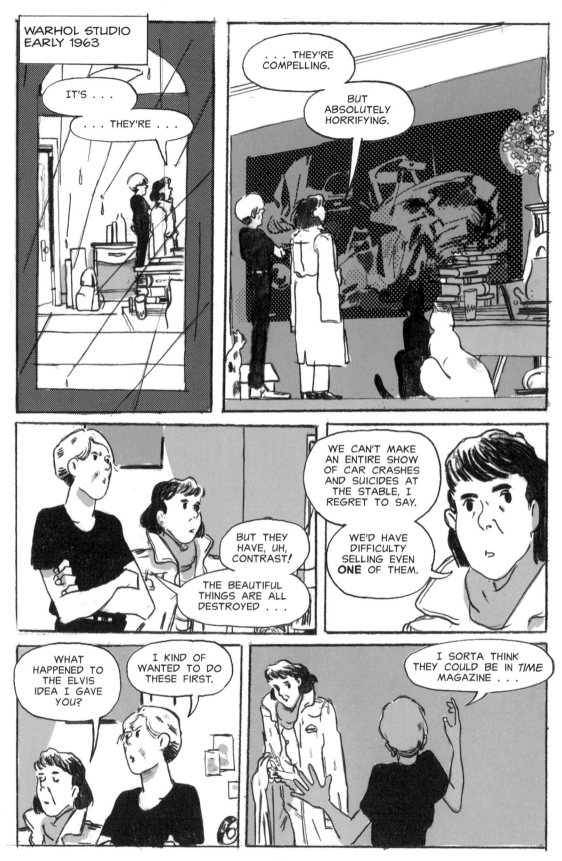

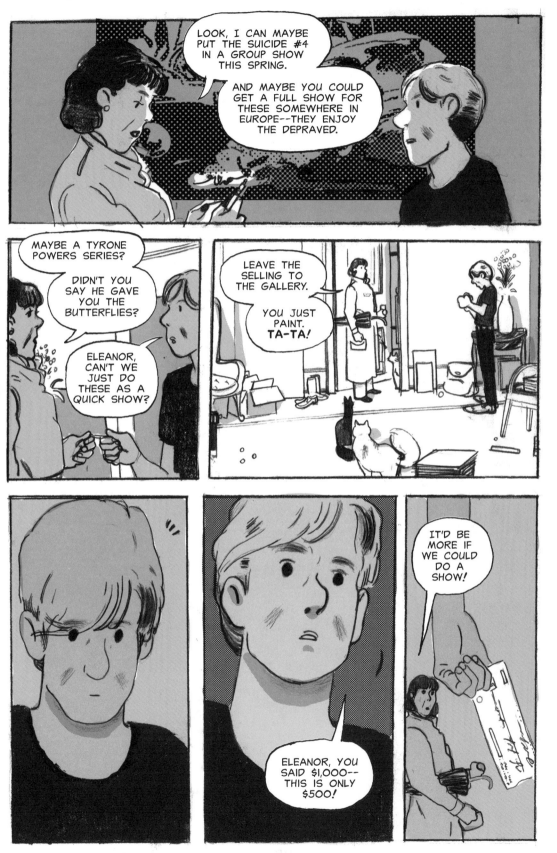

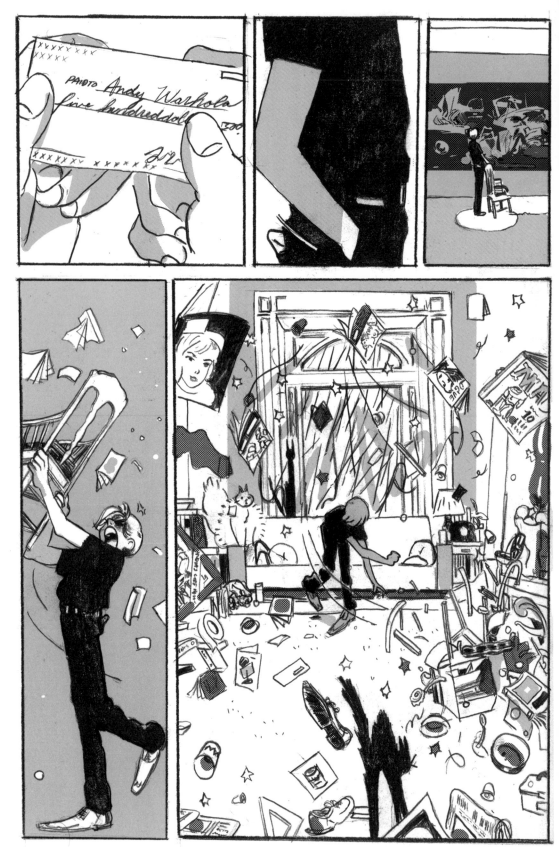

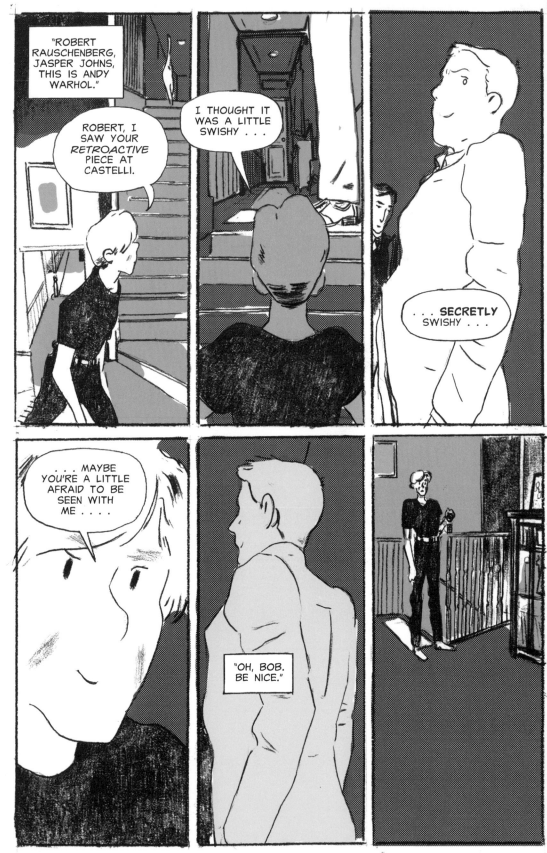

CHAPTER SIX

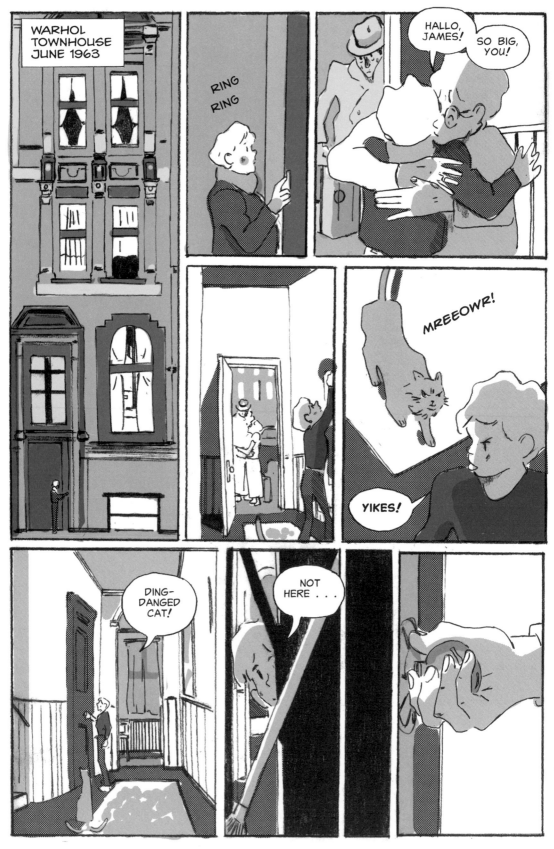

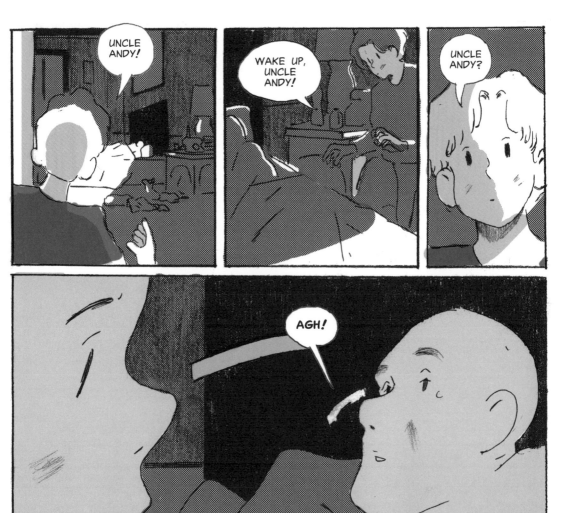

SERENDIPITY 3 CAFE
EAST 60TH STREET

PASTRIES, MY KIDDIES!

OO!

YINZ GONNA SPOIL 'EM.

AW, SHOOT! HOW OFTEN DO I GET TO SEE YOU GUYS? NEVER, I THINK.

⟨YOU COULD BE A LITTLE NICER TO MOM, THOUGH.⟩

⟨SHE'S SAYING YOU DON'T SPEND ANY TIME WITH HER SINCE YOU GOT THE NEW STUDIO.⟩

PAUL, PLEASE. SHE LIVES IN MY HOUSE.

⟨SHE SHOULD LIVE WITH ME AND THE KIDS, ANDY.⟩

OH MY GOSH, GUYS, YOU **HAVE** TO HAVE THE MONTELIMAR! **SO GOOD.**

I WANT ONE!

⟨SHE SHOULD COME HOME. NEW YORK IS TOO CRAZY.⟩

I NEED MOM TO STAY HERE. ⟨SHE'S STAYING. END OF STORY.⟩

HOW MANY CAN YOU KIDS EAT AT THE SAME TIME?

A HUNDRED!

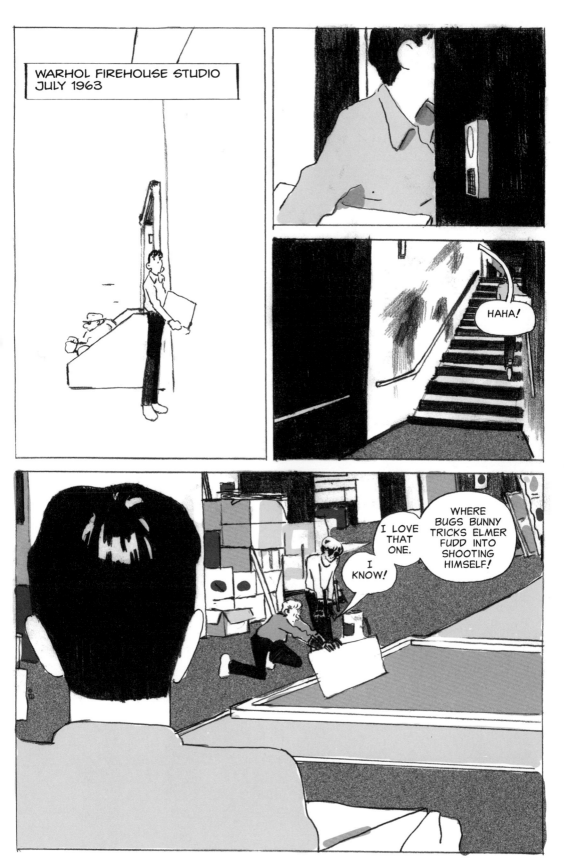

WARHOL FIREHOUSE STUDIO
JULY 1963

HAHA!

I LOVE THAT ONE.

I KNOW!

WHERE BUGS BUNNY TRICKS ELMER FUDD INTO SHOOTING HIMSELF!

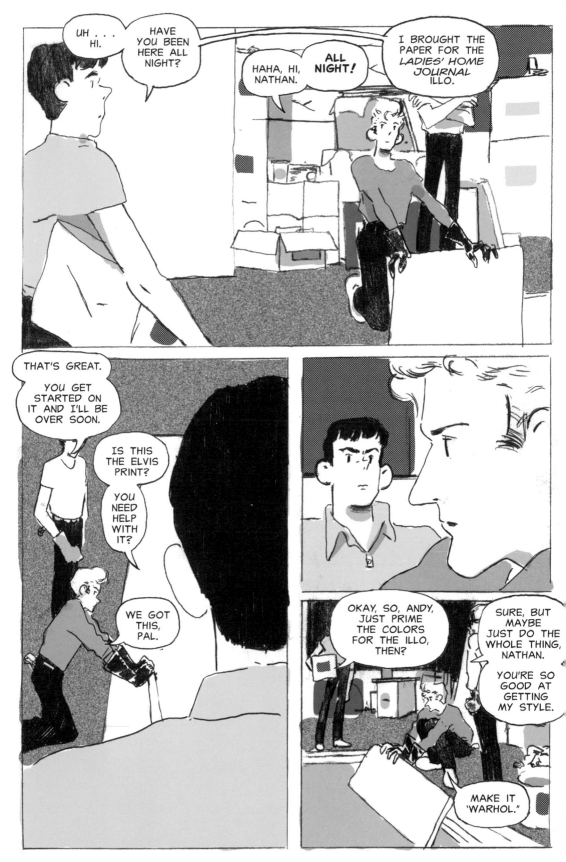

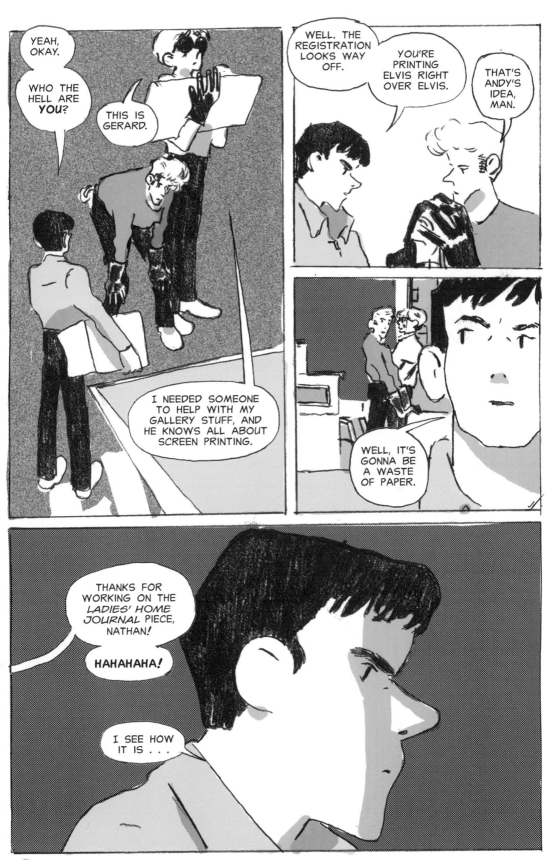

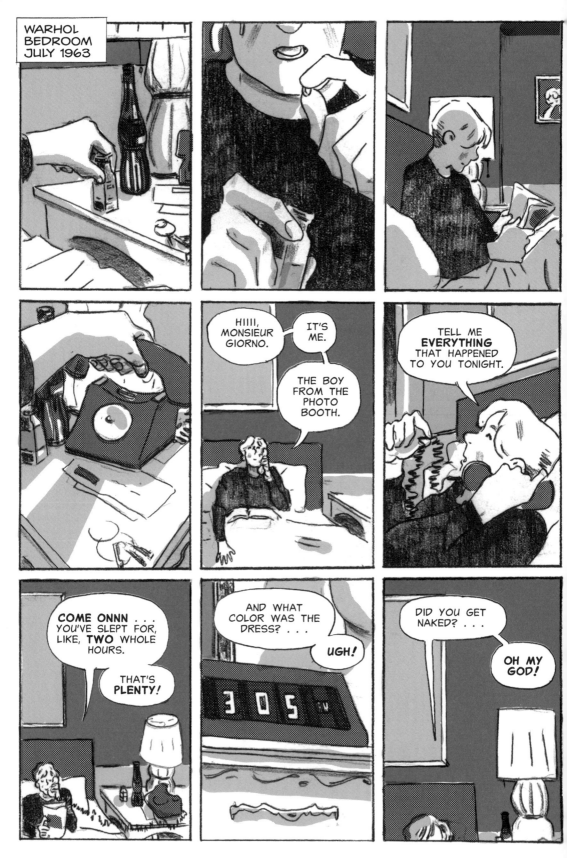

CHAPTER SEVEN

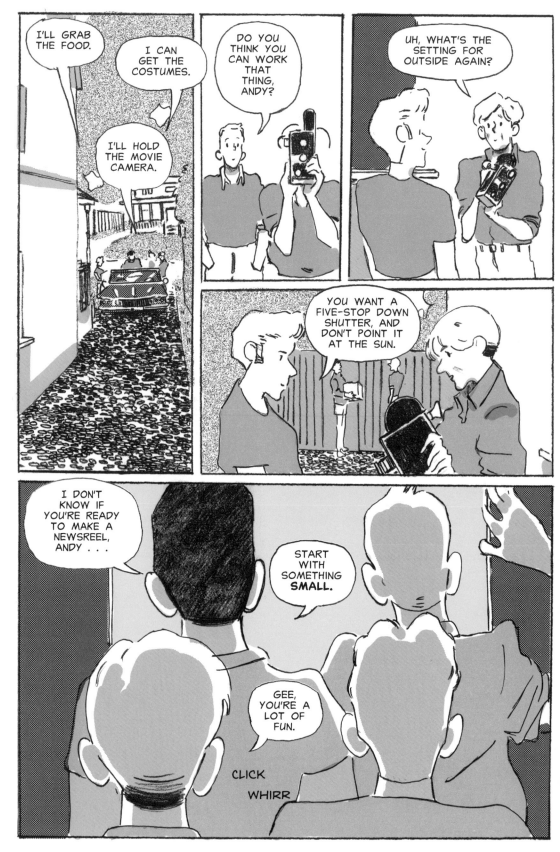

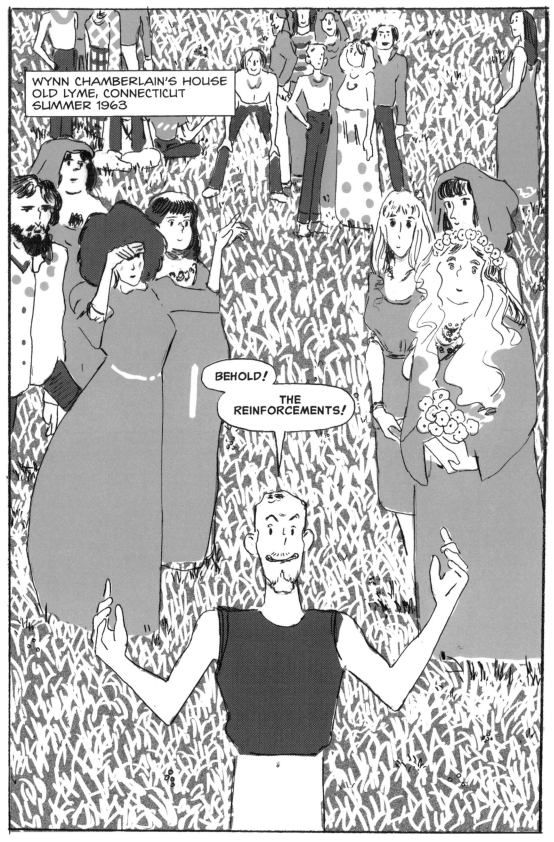

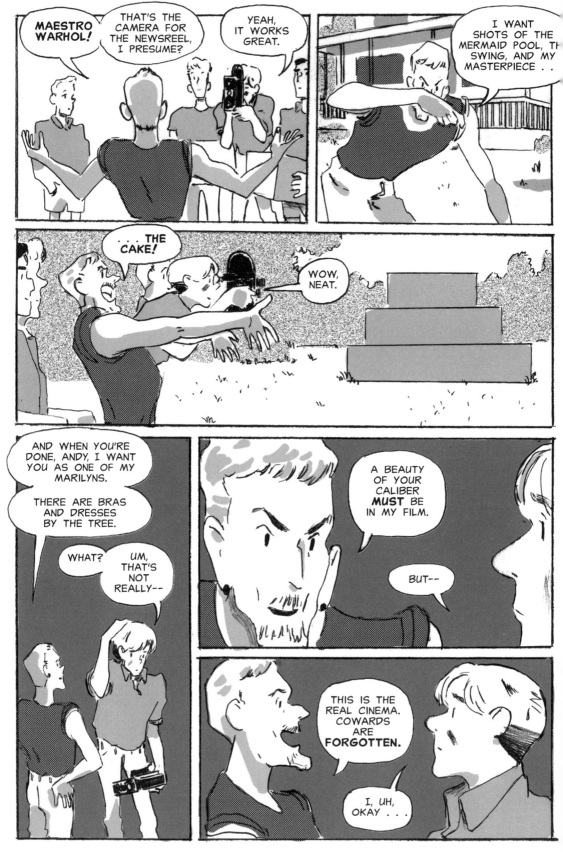

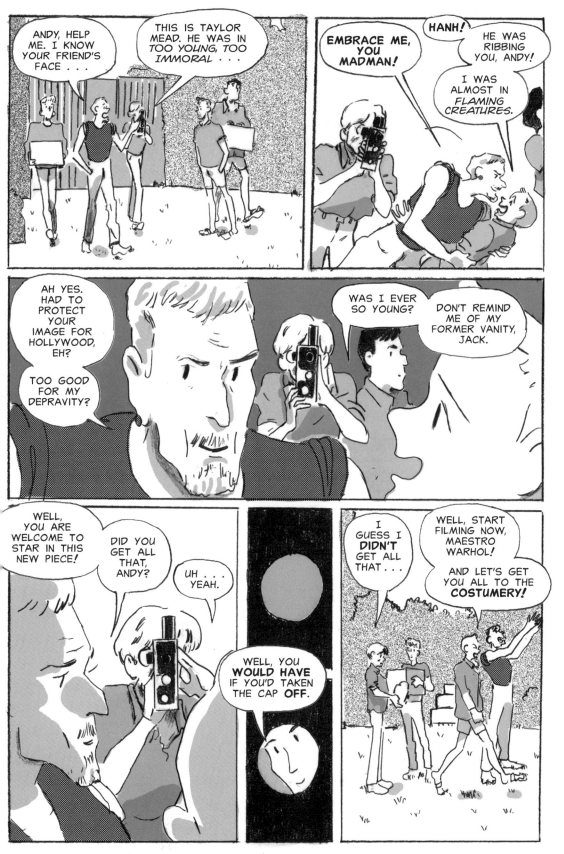

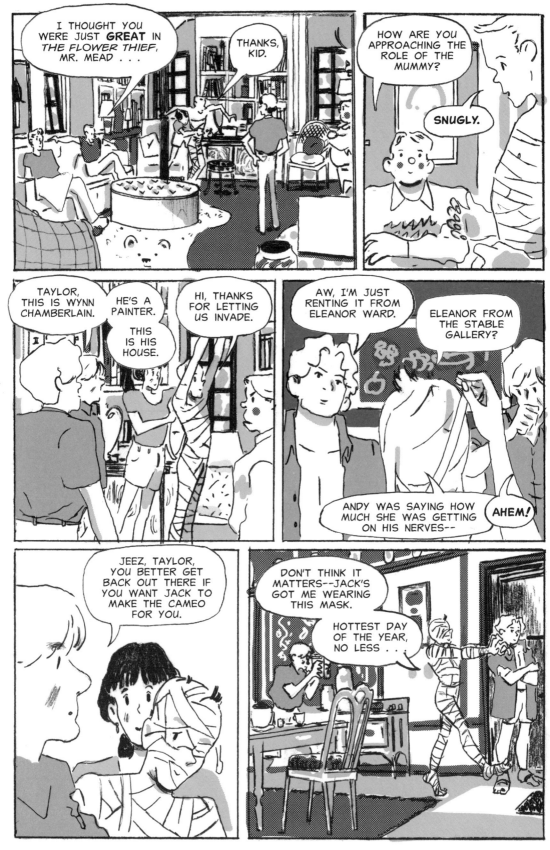

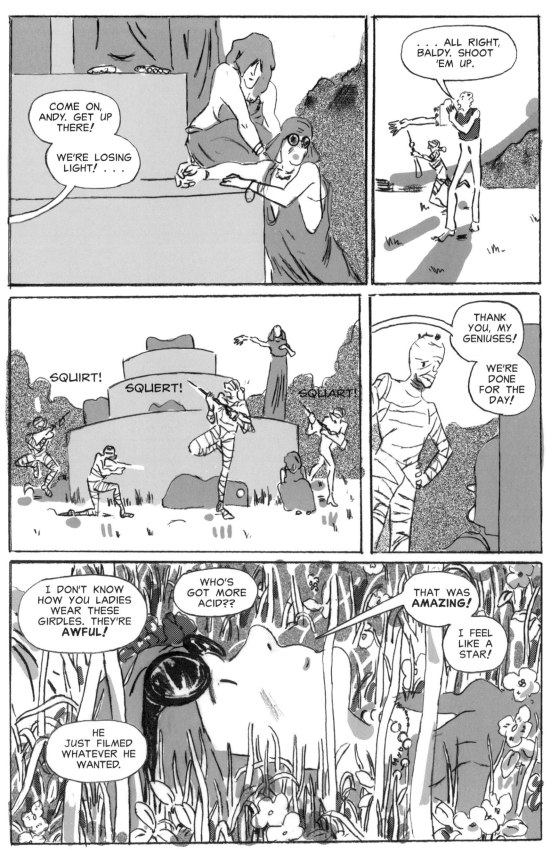

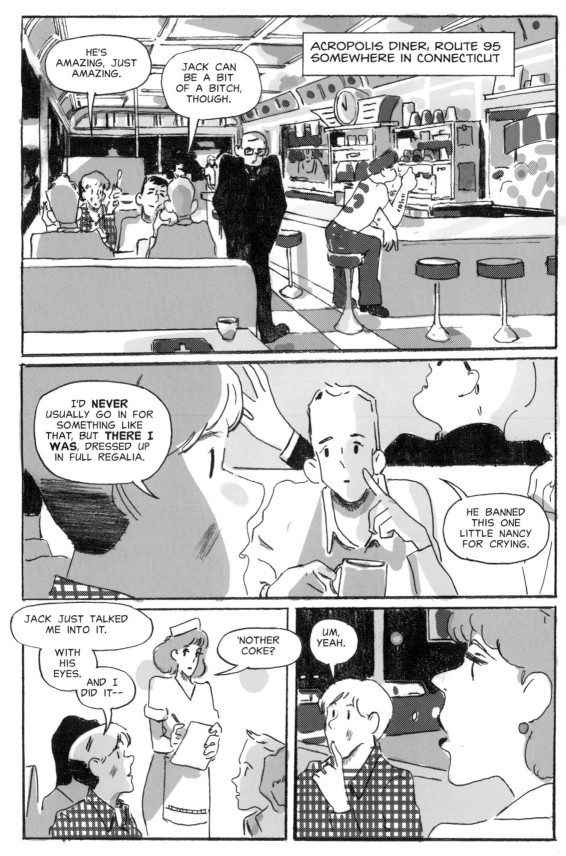

CHAPTER EIGHT

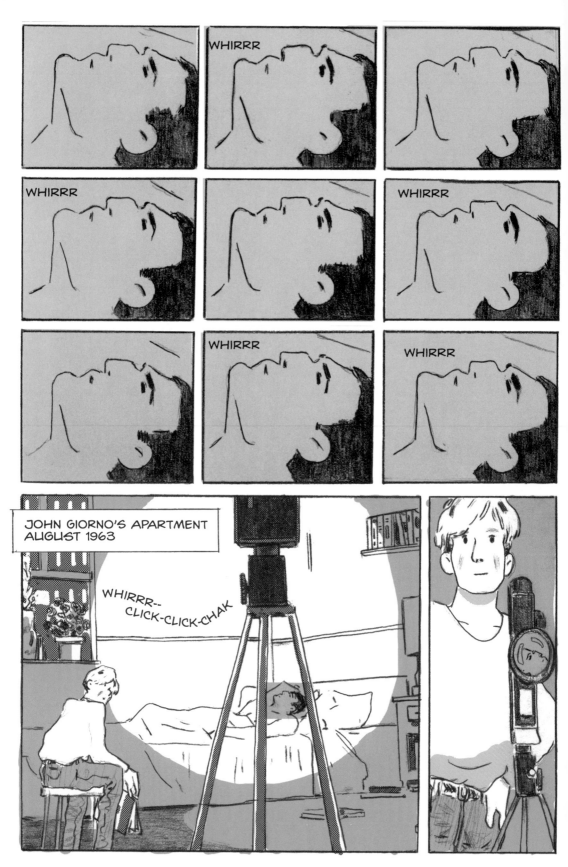

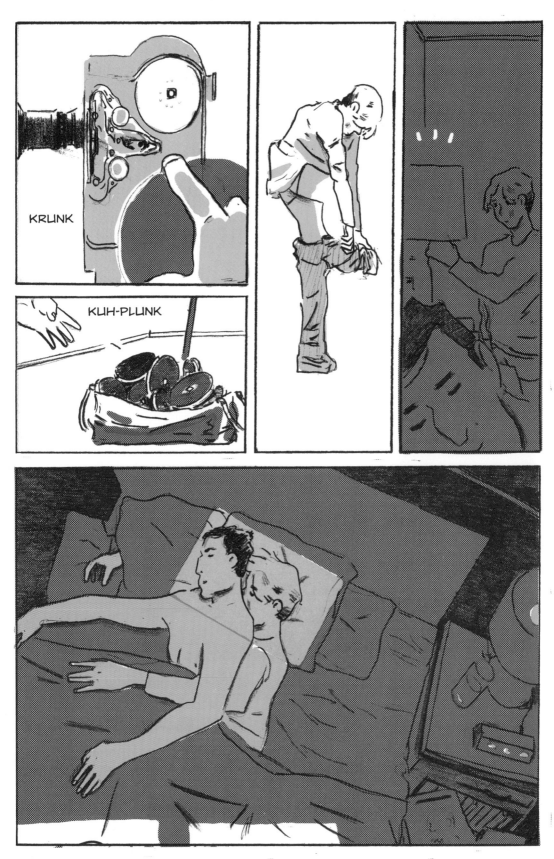

CHAPTER NINE

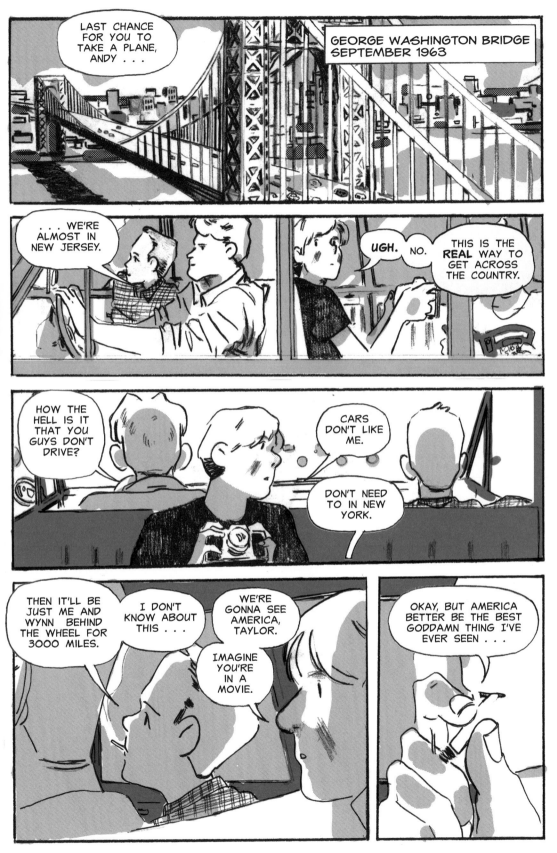

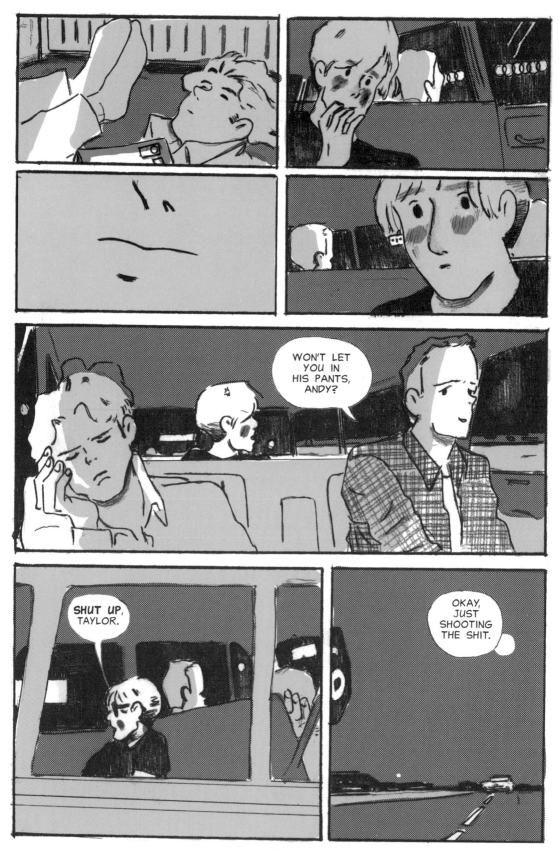

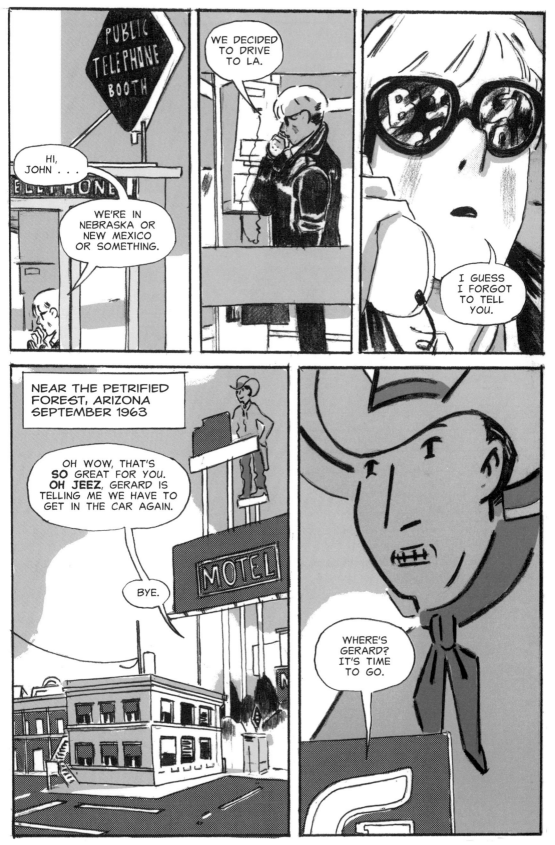

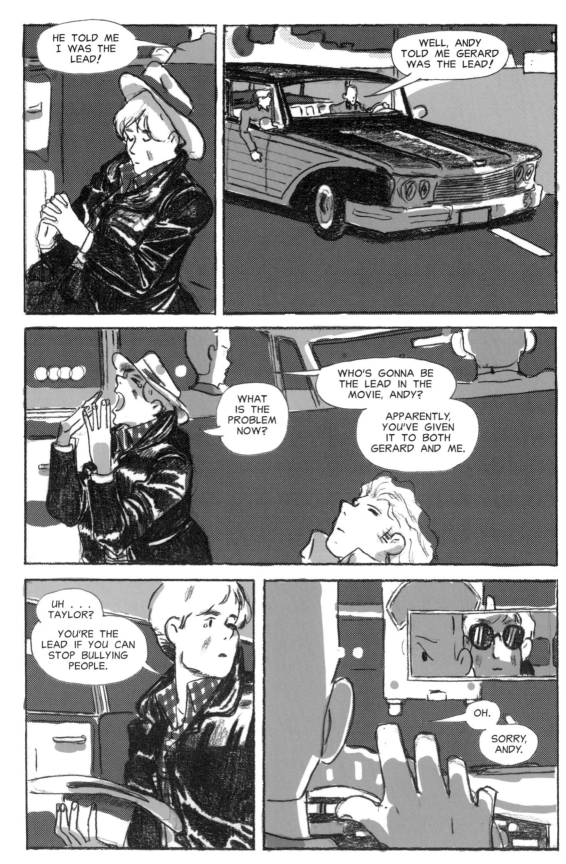

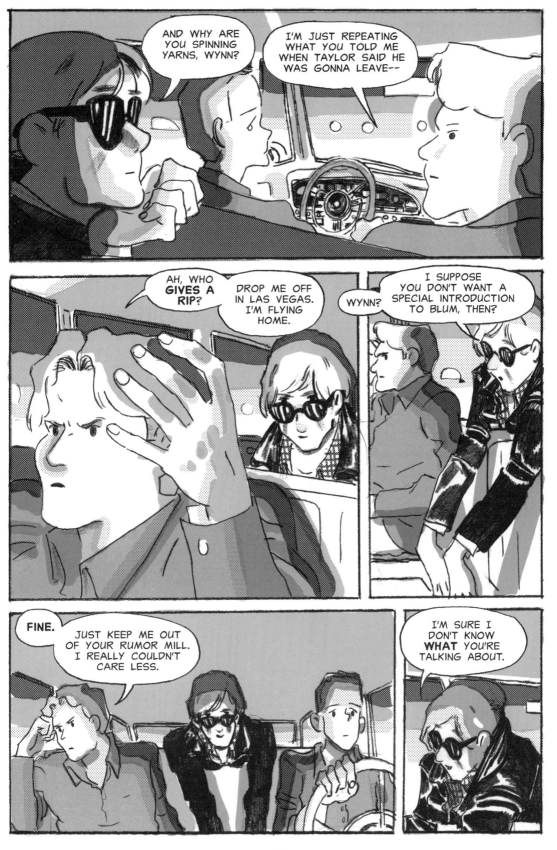

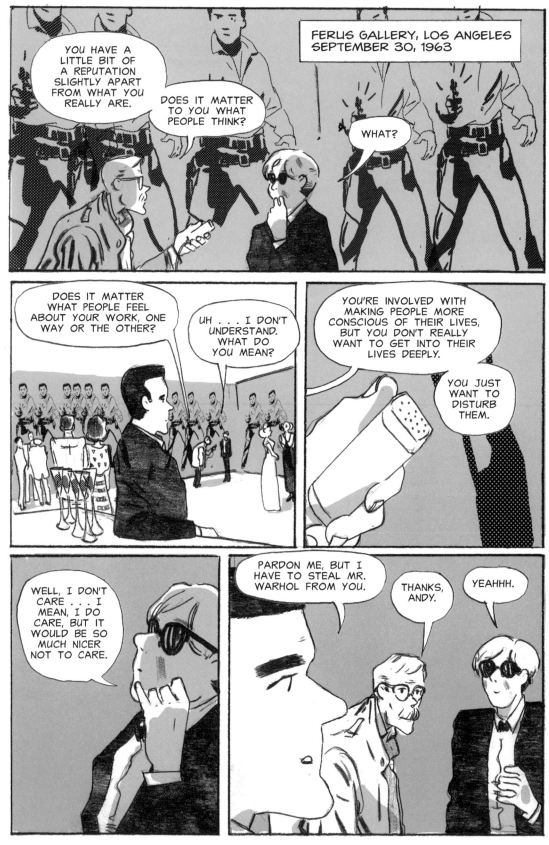

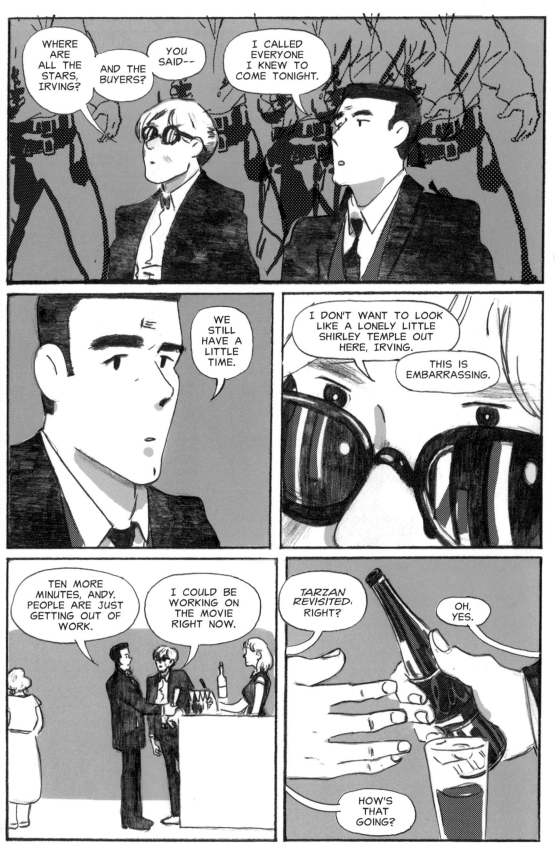

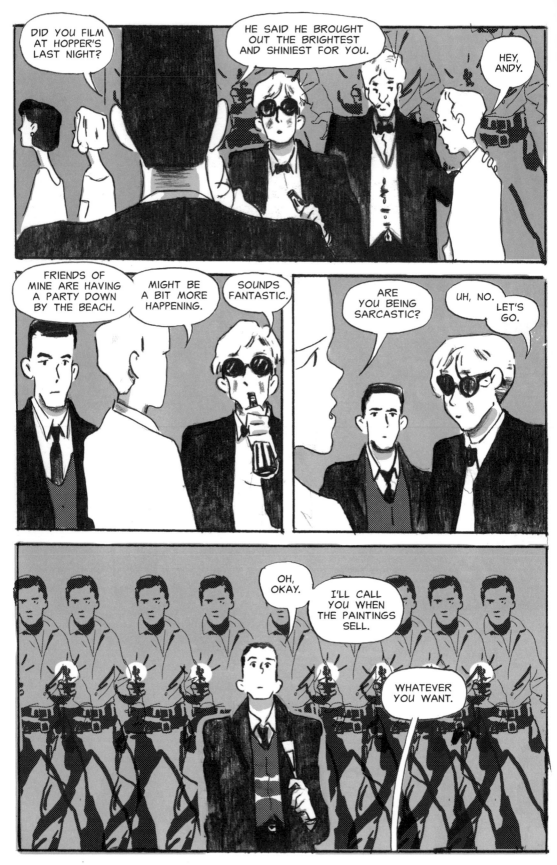

76

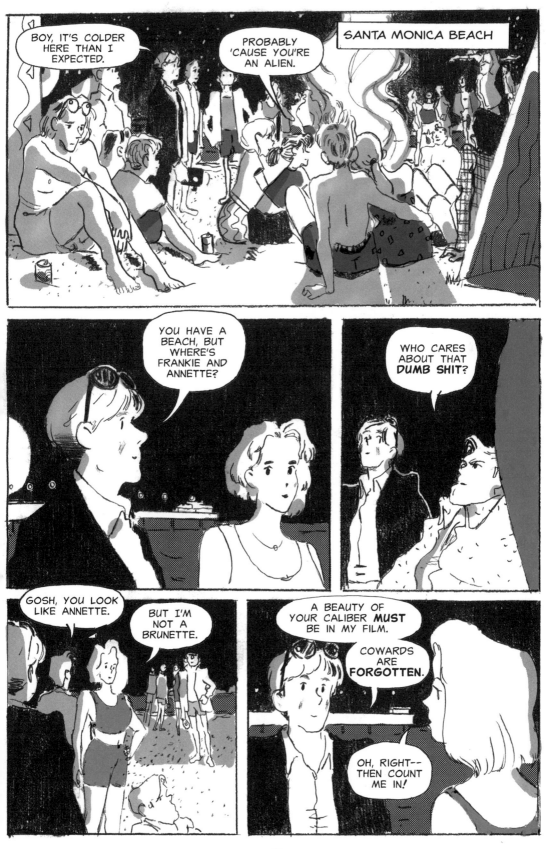

77

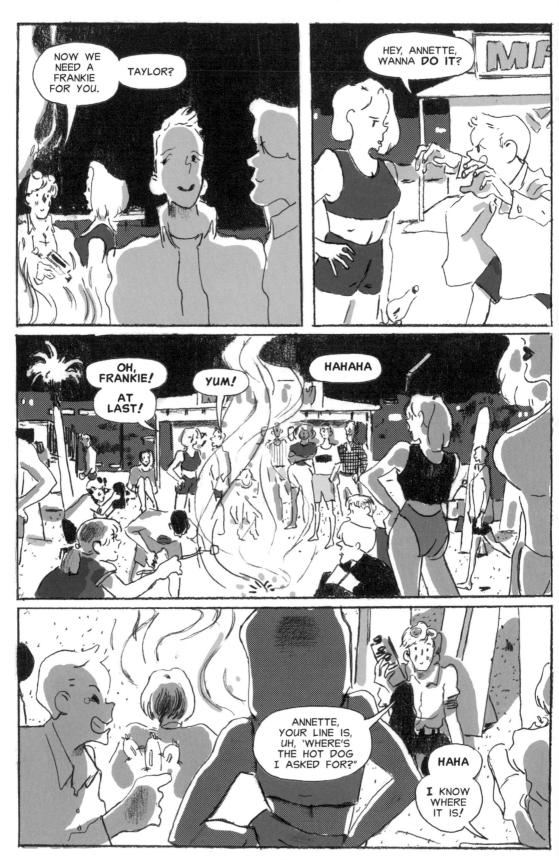

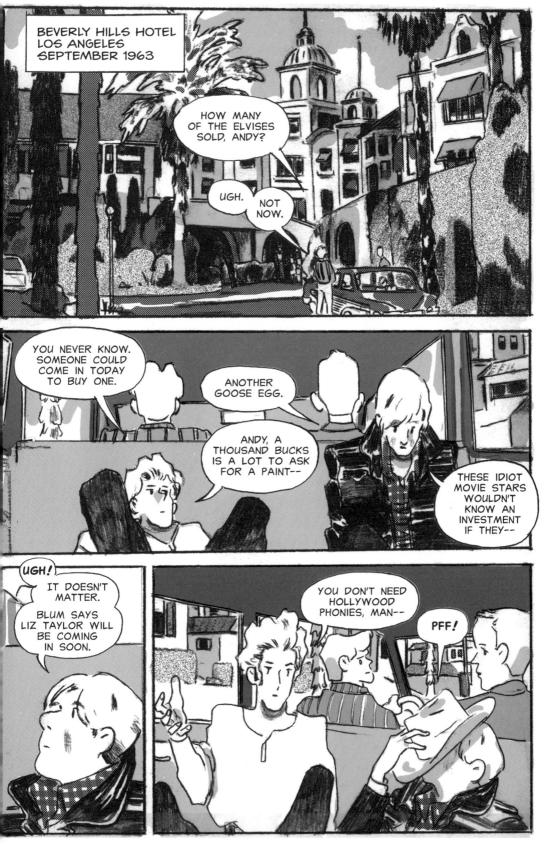

CHAPTER TEN

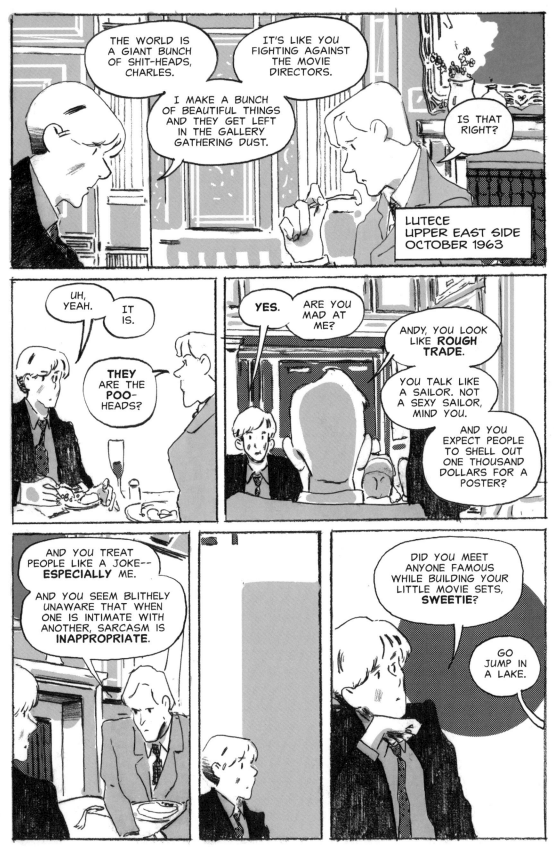

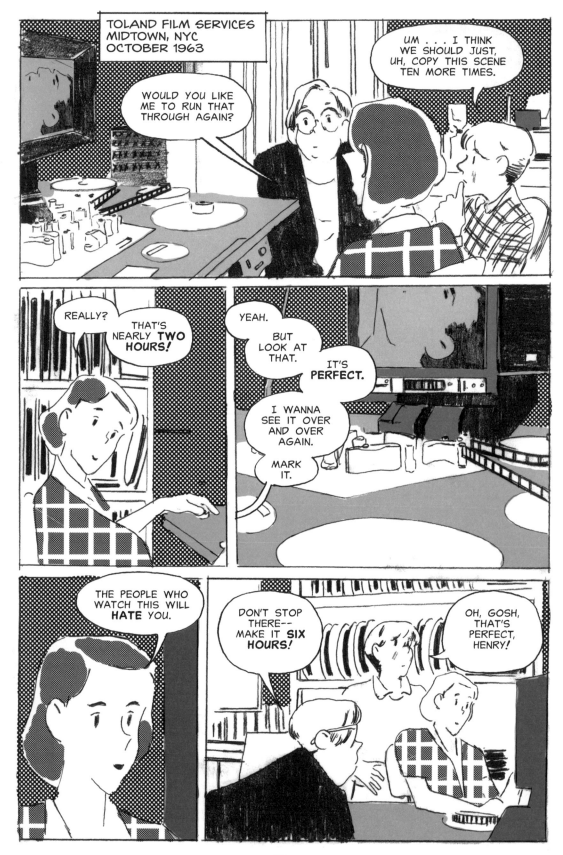

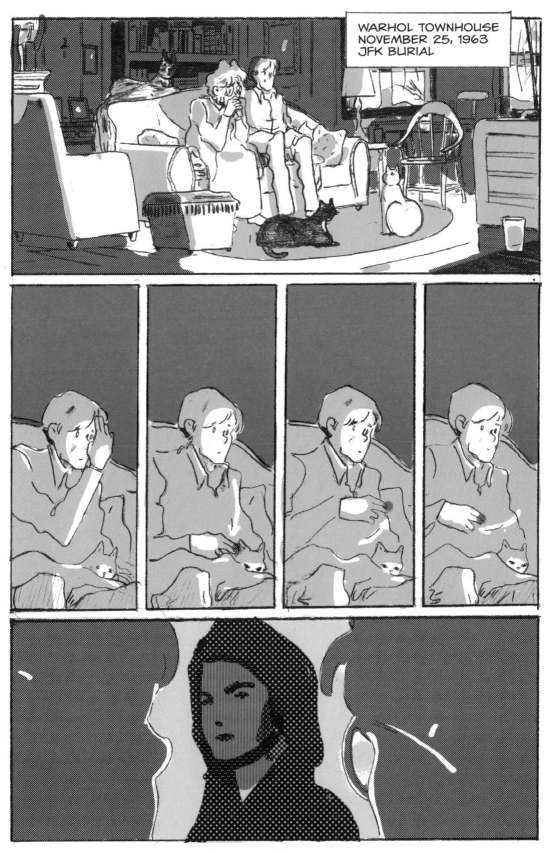

WARHOL TOWNHOUSE
NOVEMBER 25, 1963
JFK BURIAL

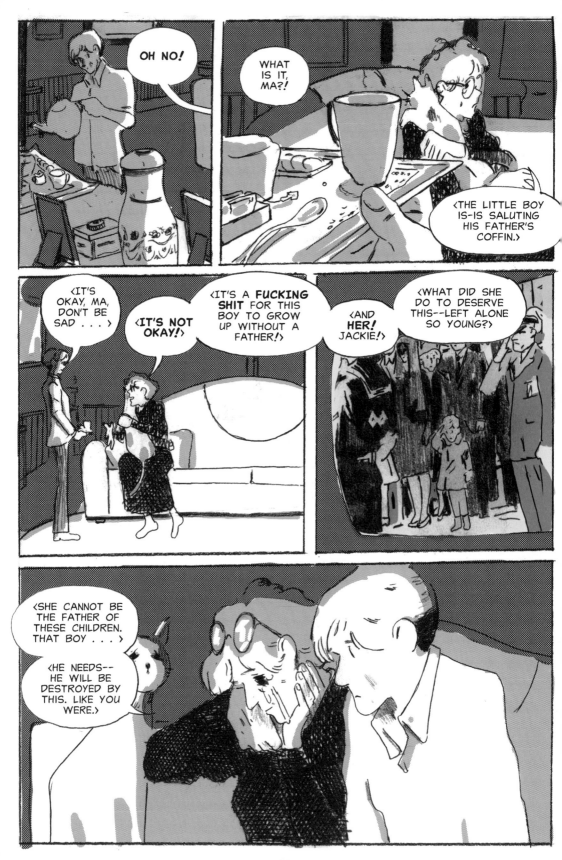

CHAPTER ELEVEN

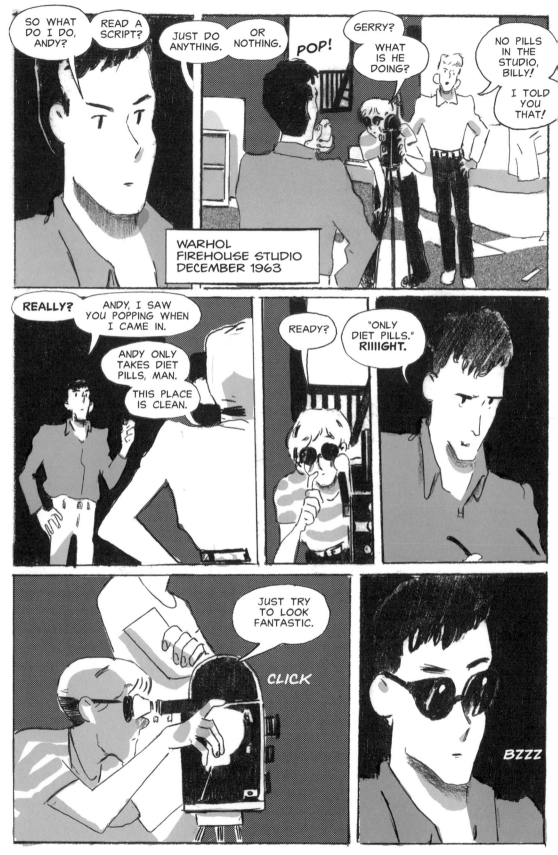

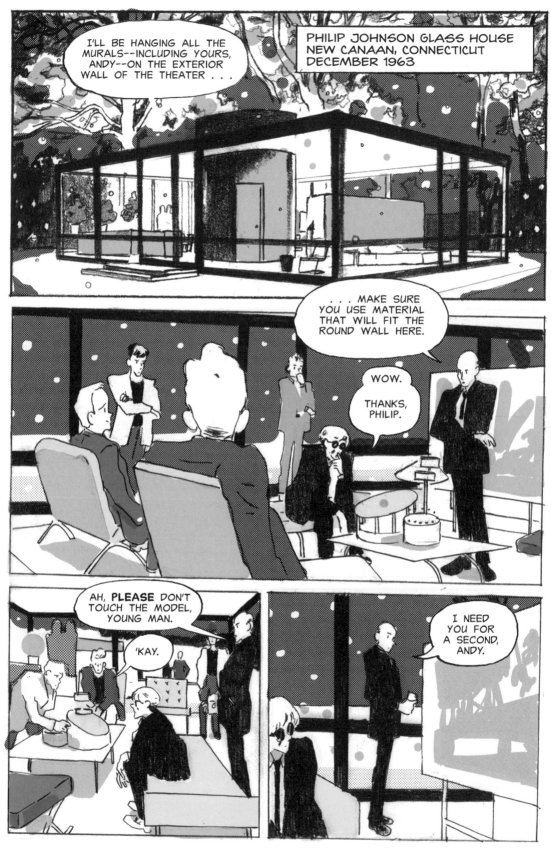

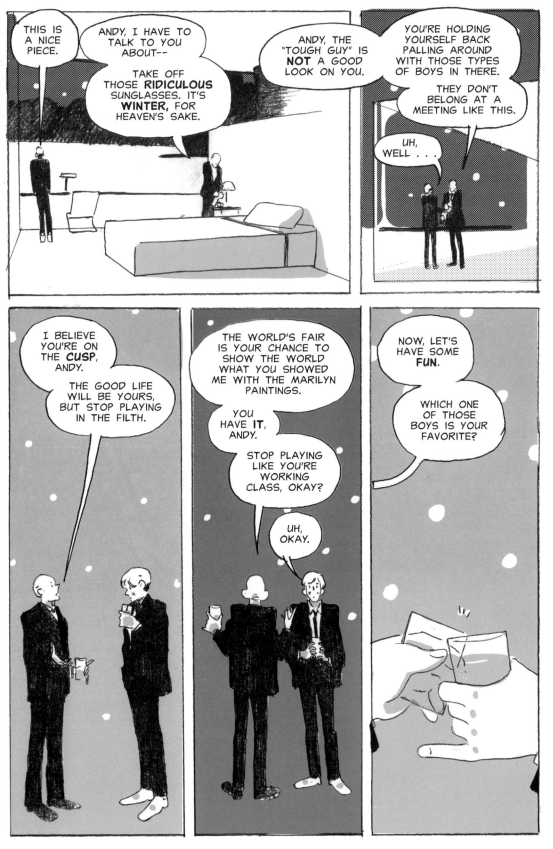

CHAPTER TWELVE

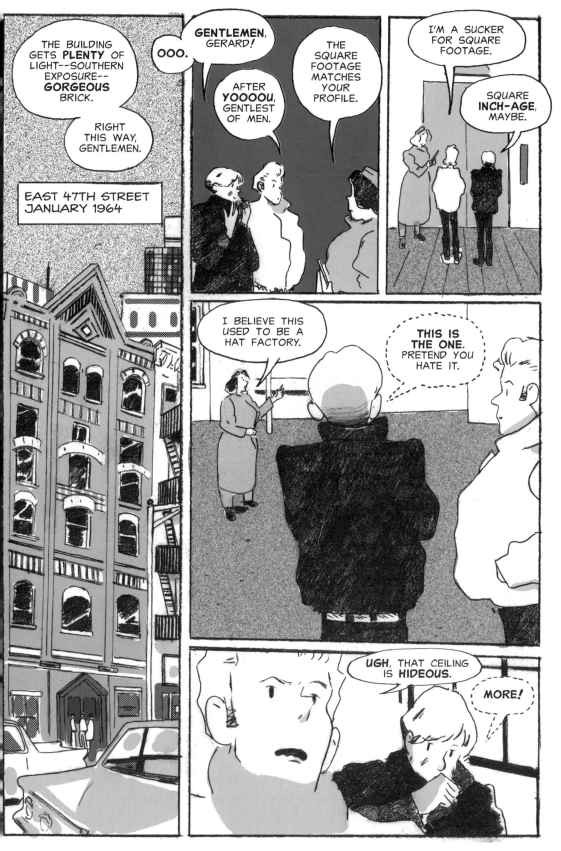

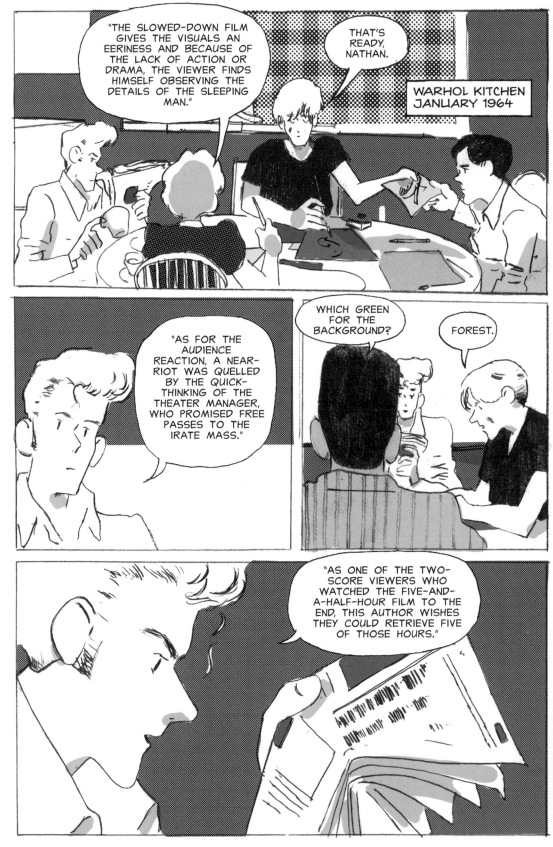

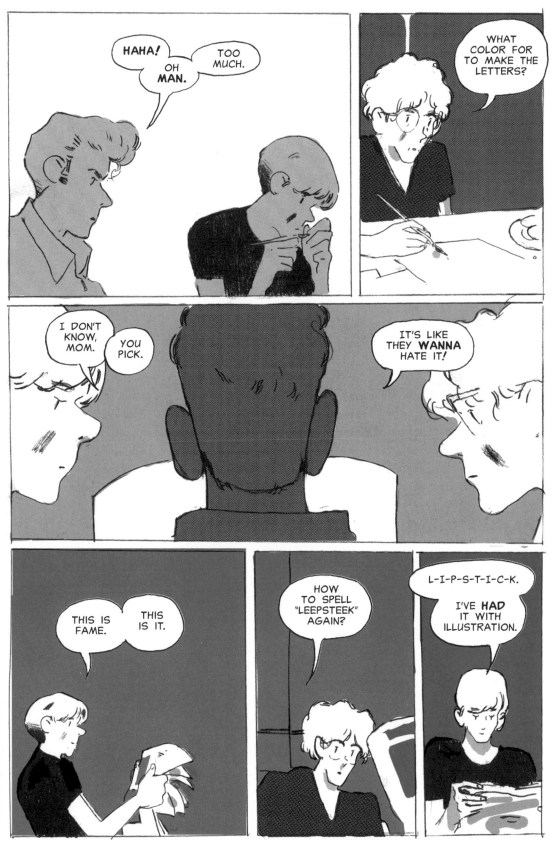

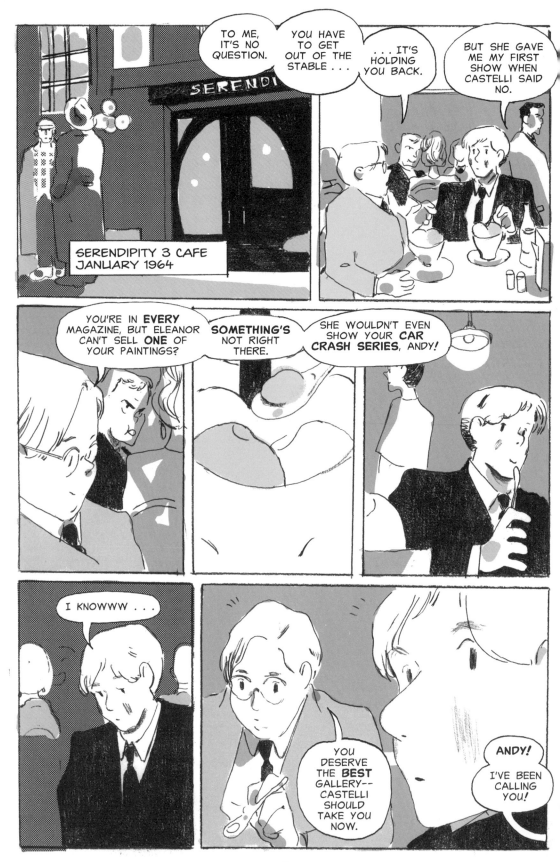

SERENDIPITY 3 CAFE
JANUARY 1964

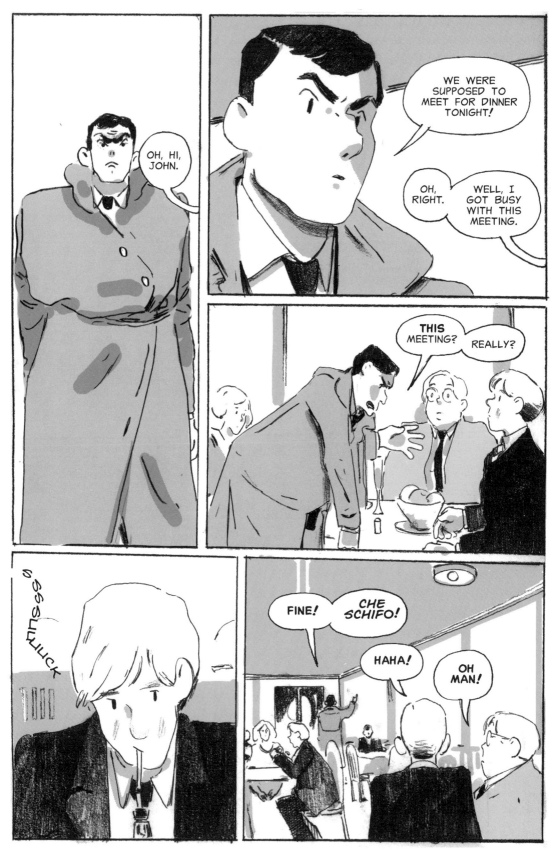

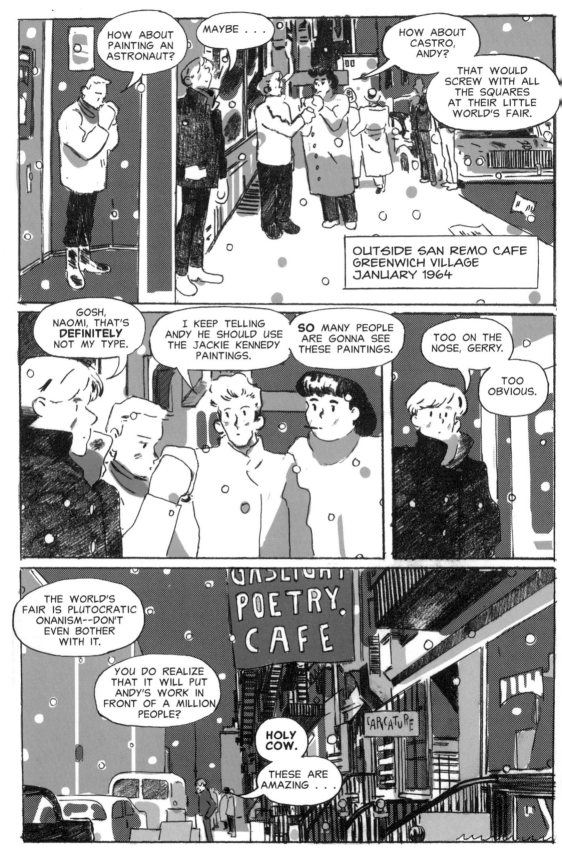

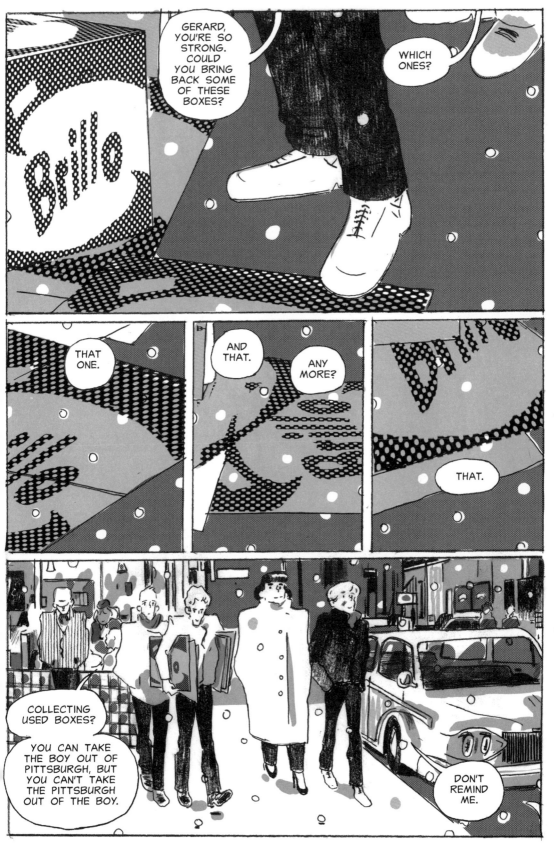

CHAPTER THIRTEEN

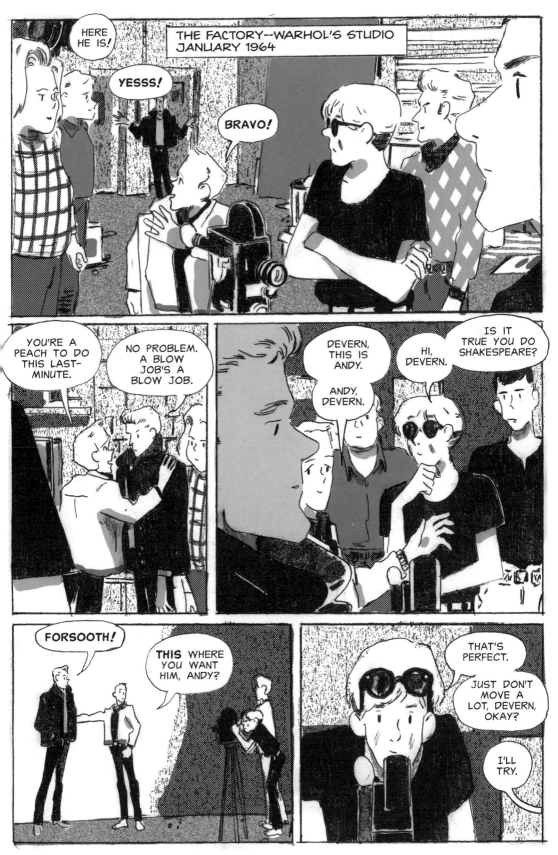

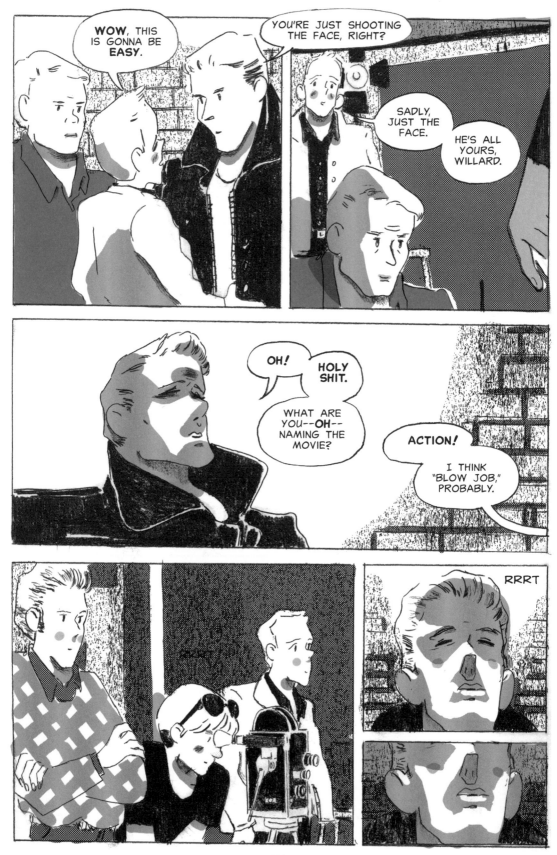

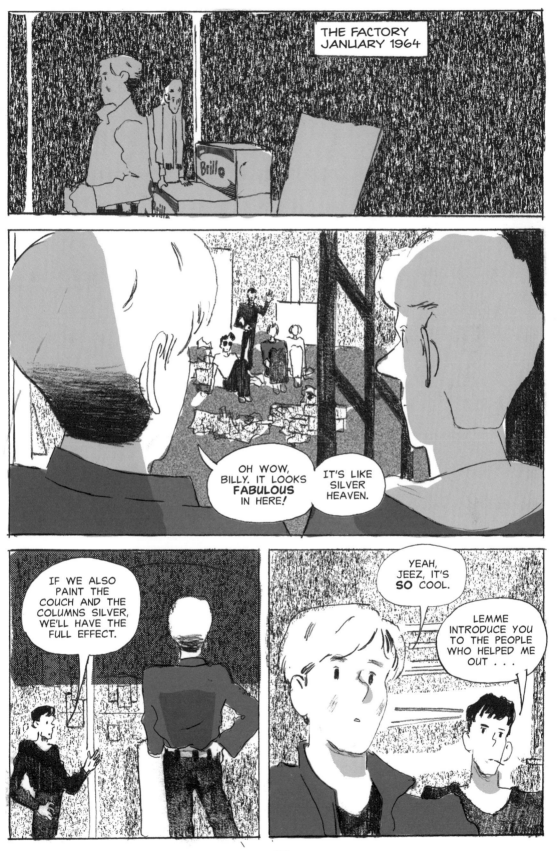

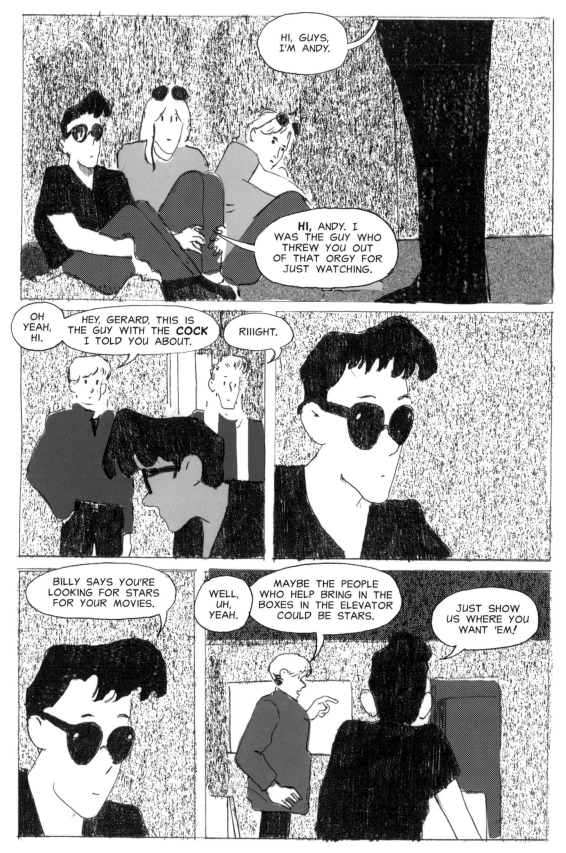

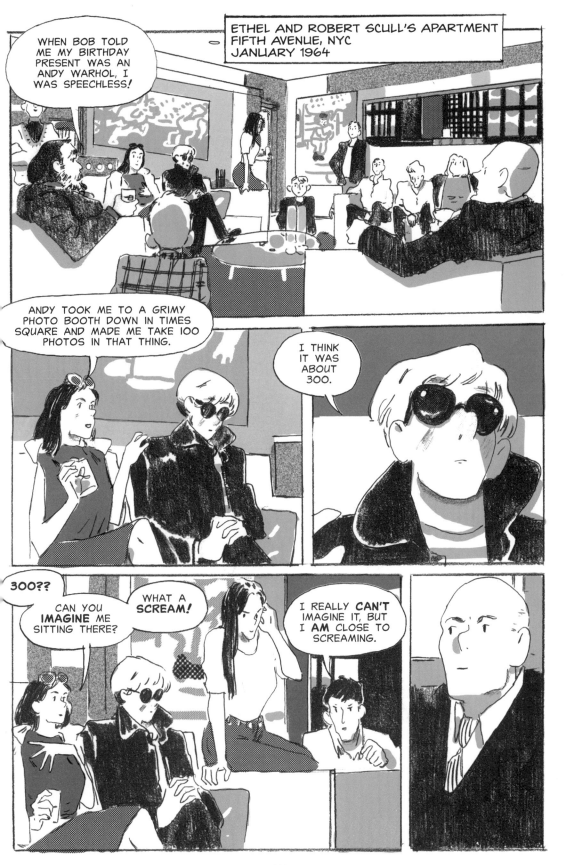

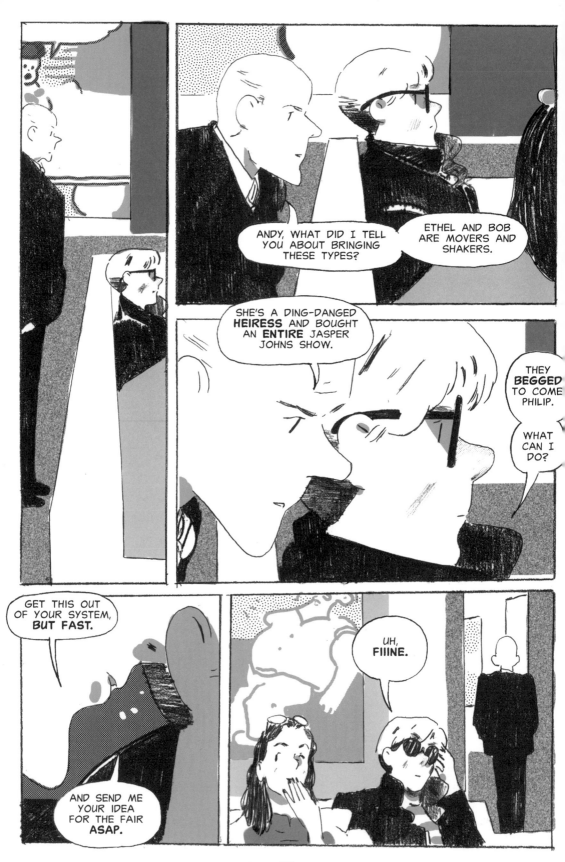

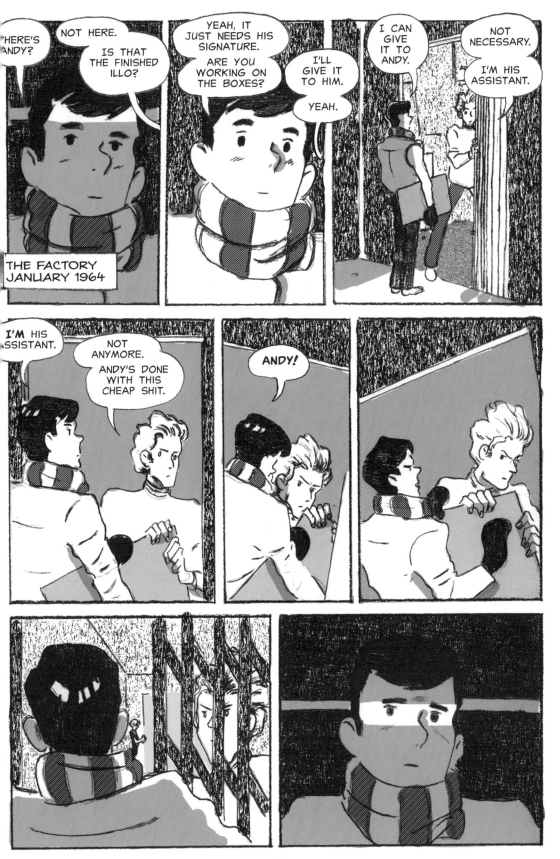

105

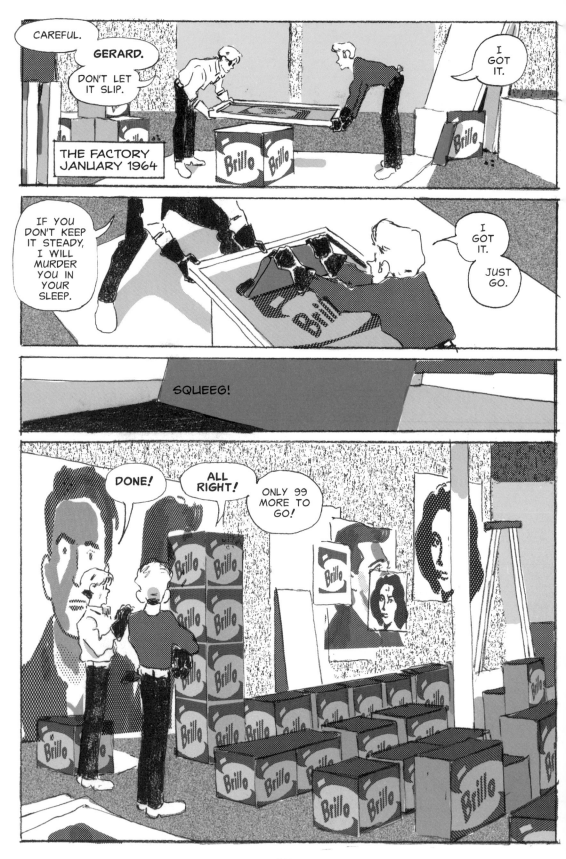

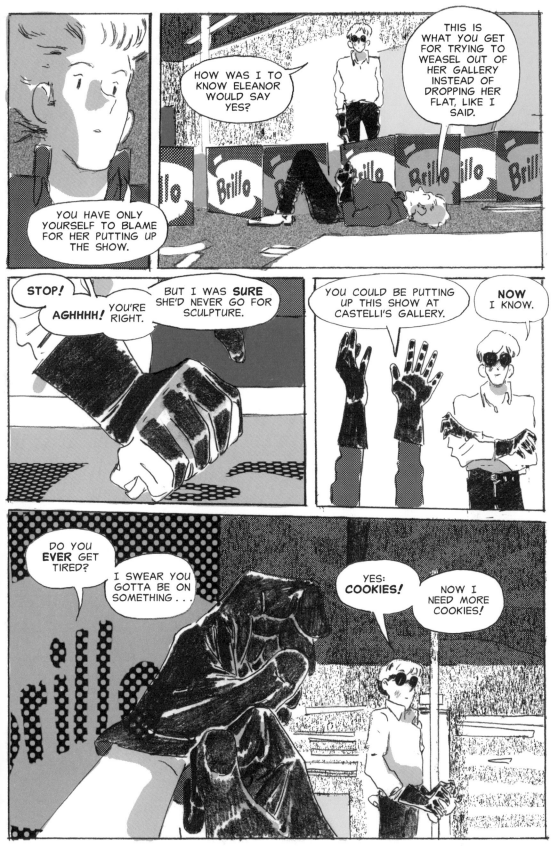

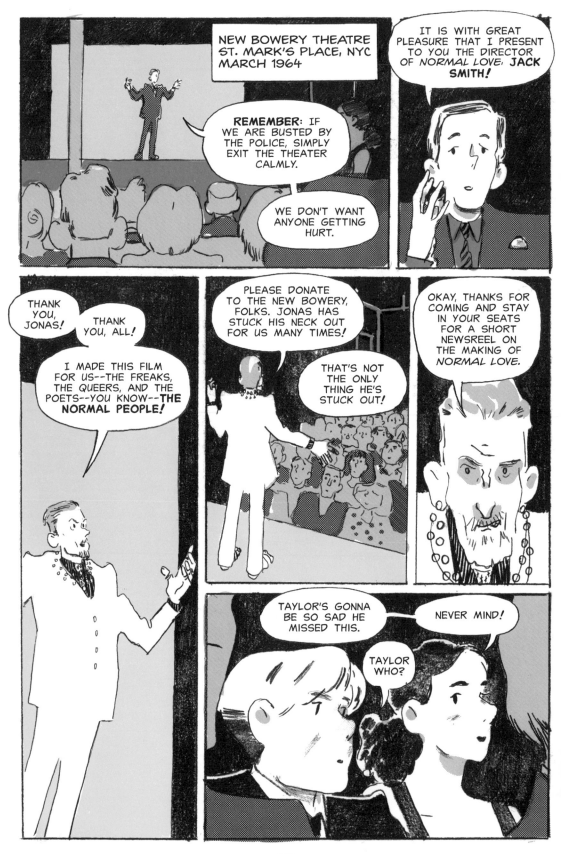

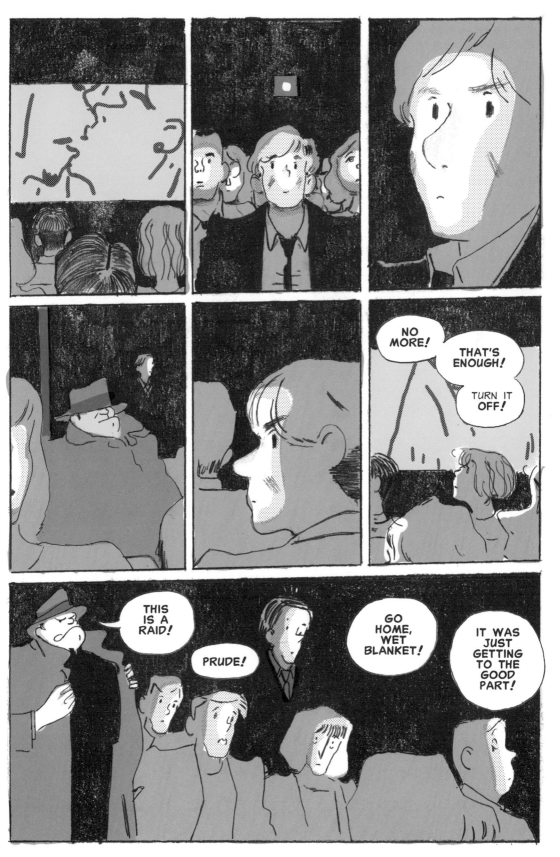

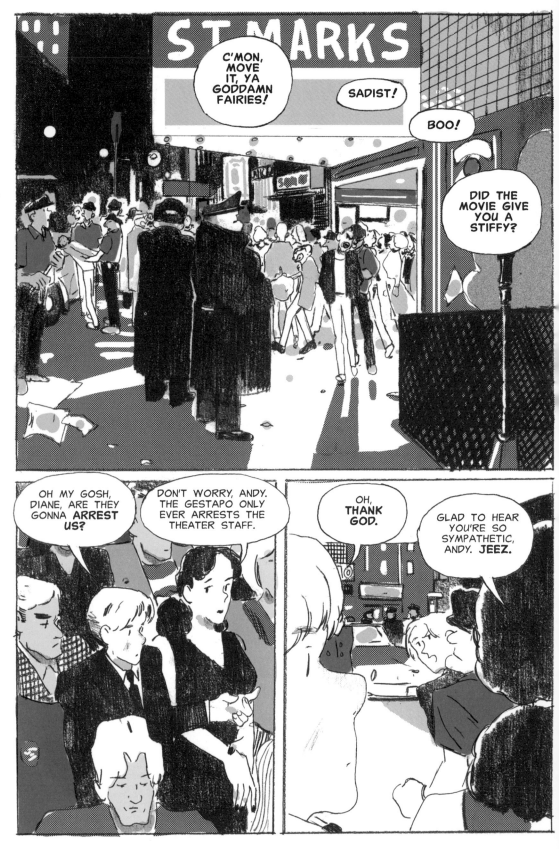

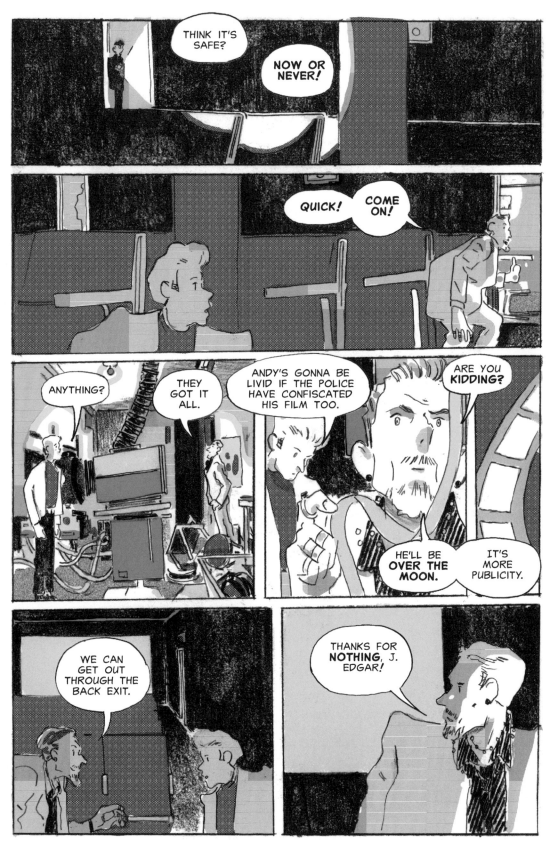

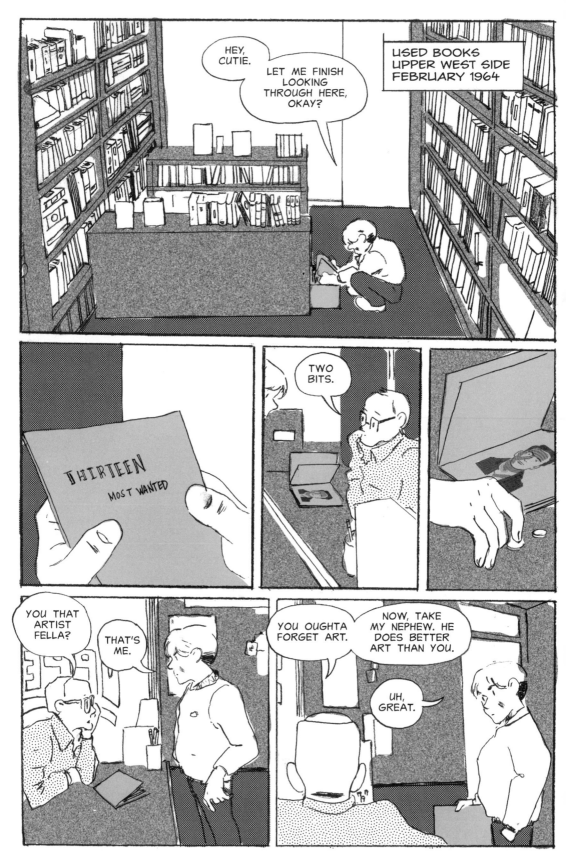

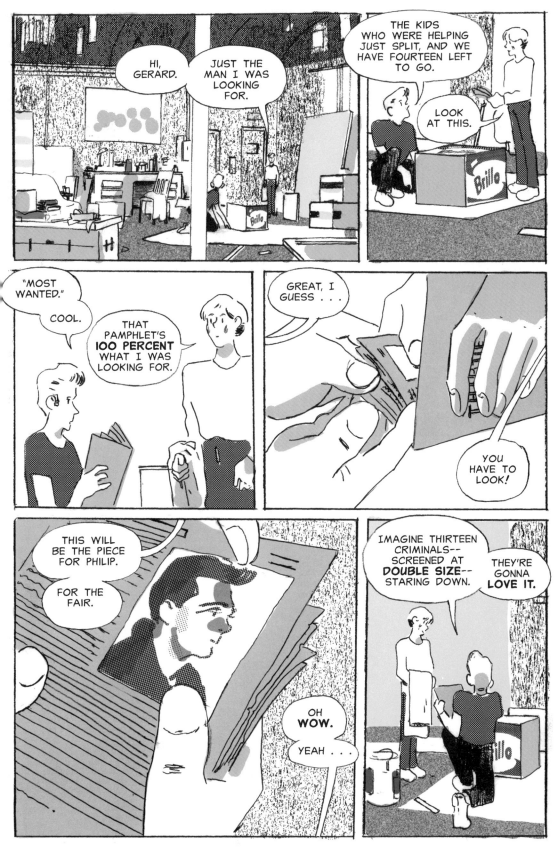

CHAPTER FOURTEEN

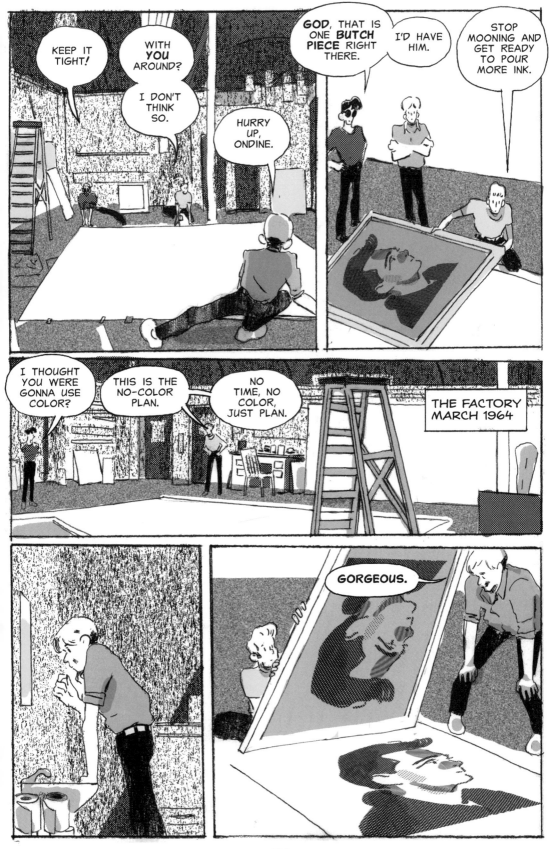

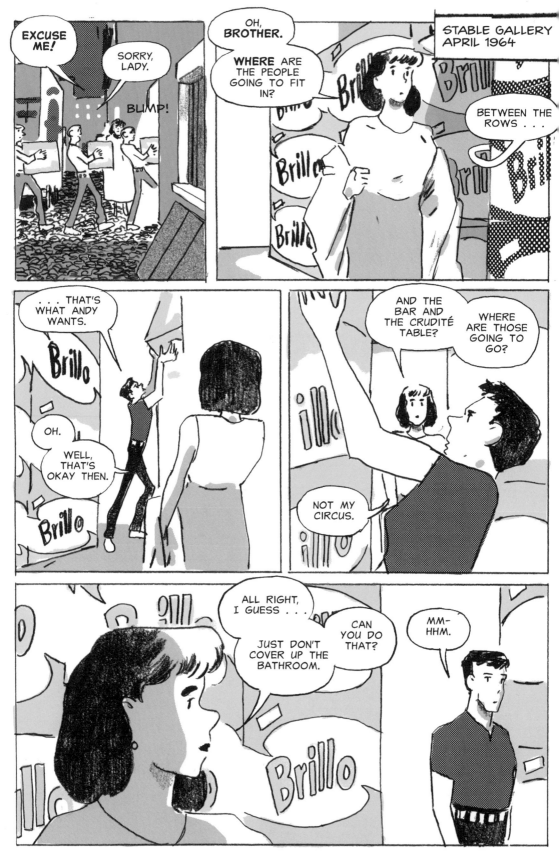

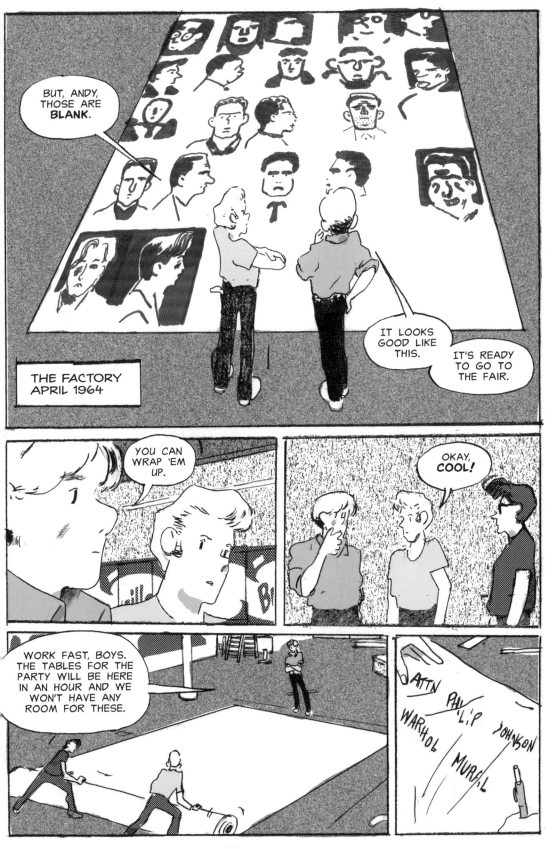

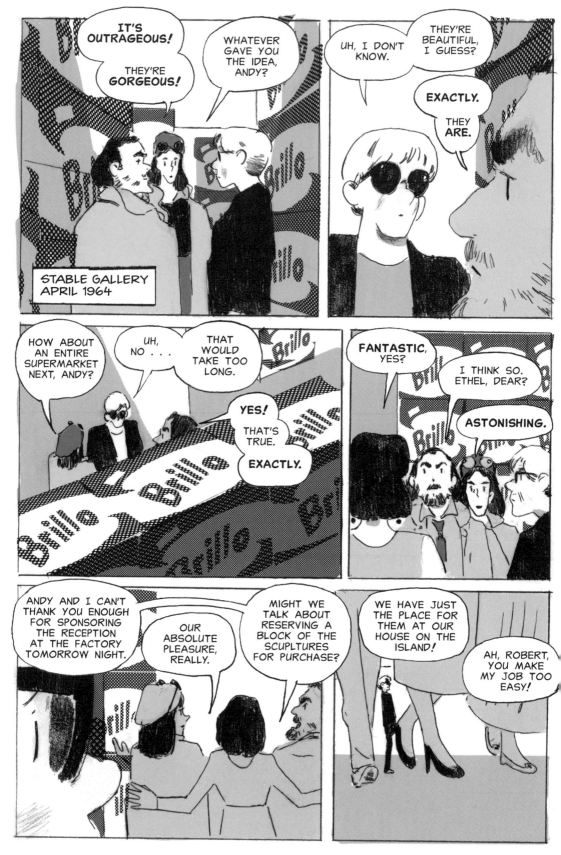

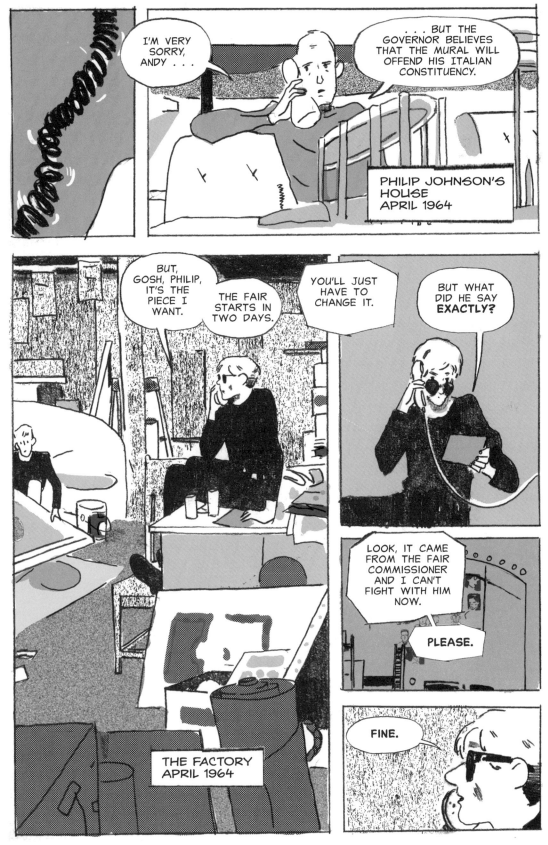

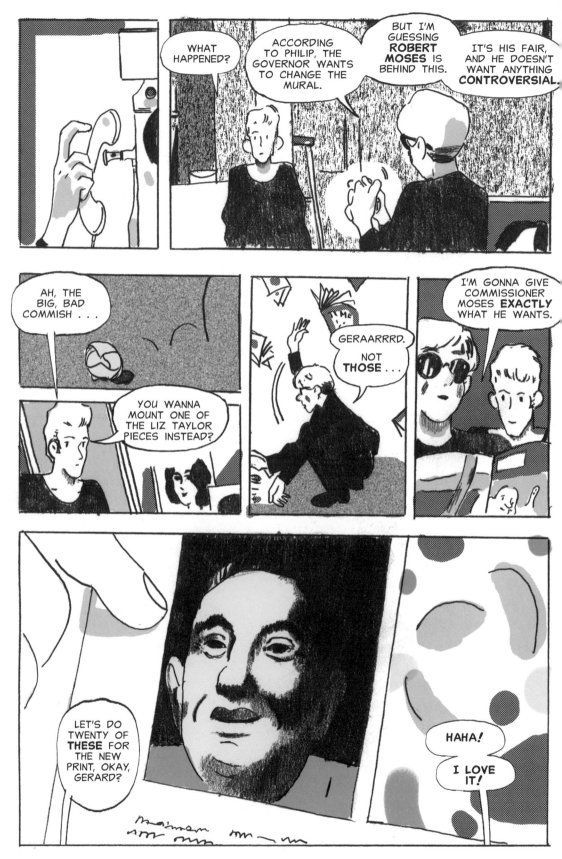

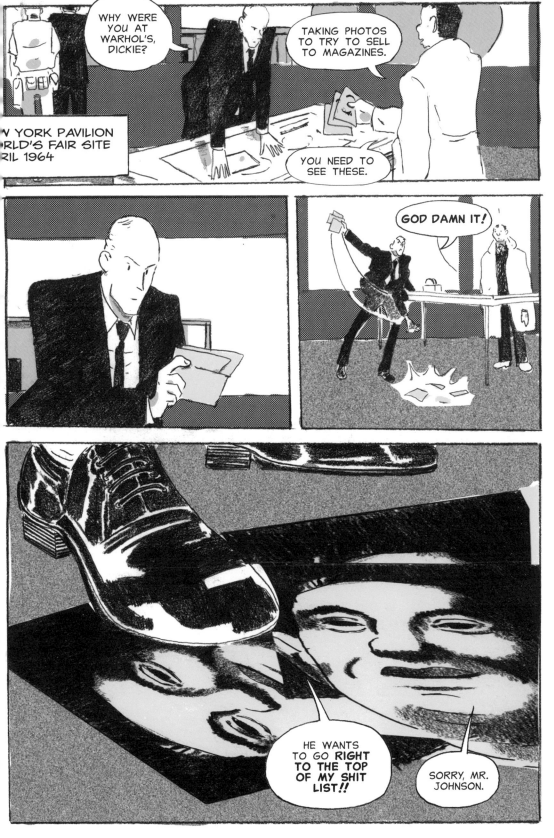

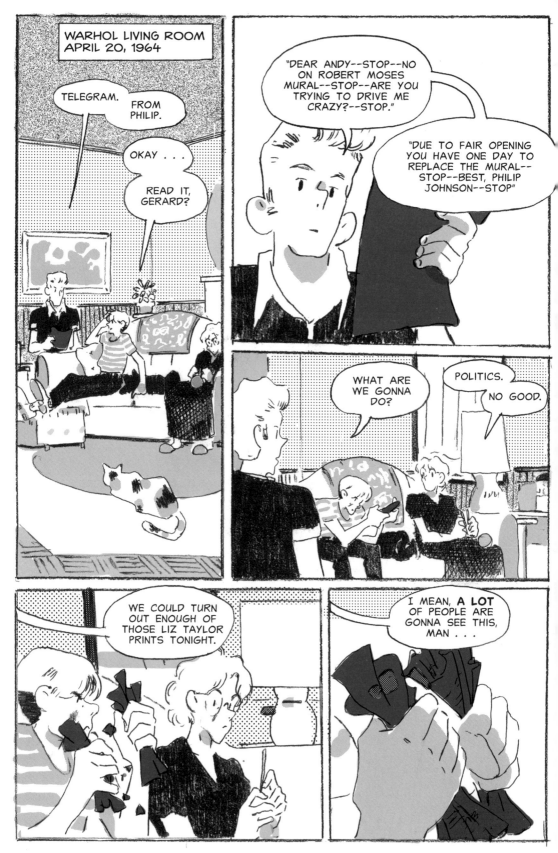

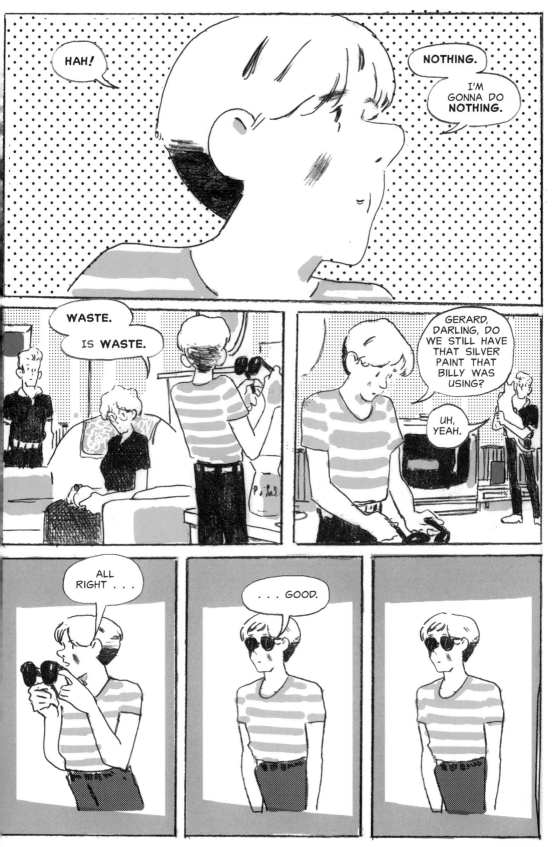

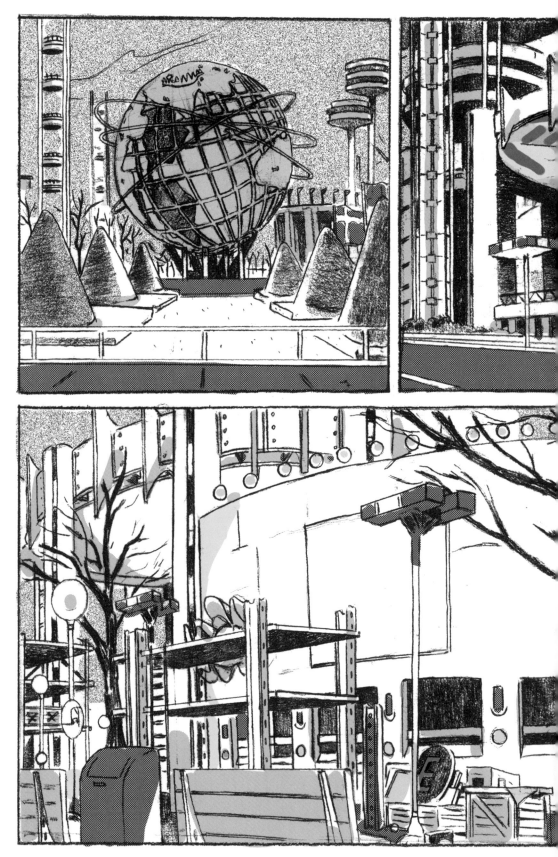

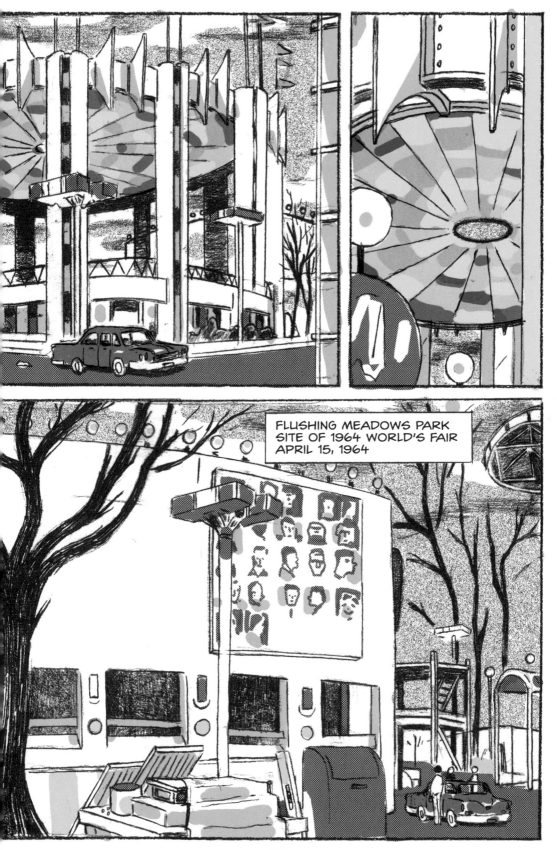

FLUSHING MEADOWS PARK
SITE OF 1964 WORLD'S FAIR
APRIL 15, 1964

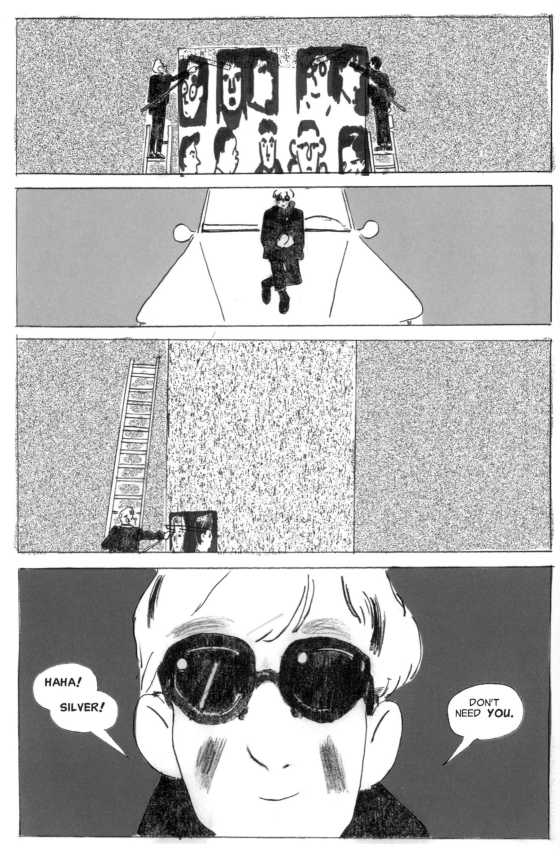

CHAPTER FIFTEEN

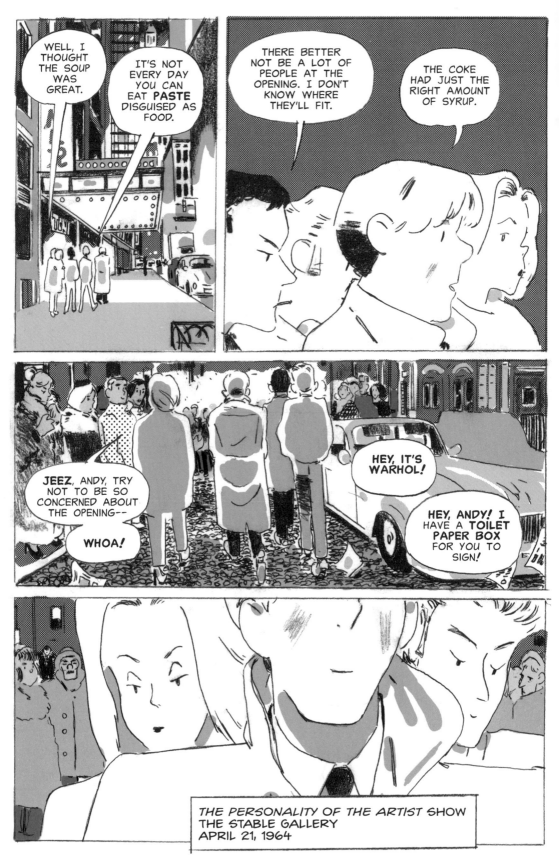

THE PERSONALITY OF THE ARTIST SHOW
THE STABLE GALLERY
APRIL 21, 1964

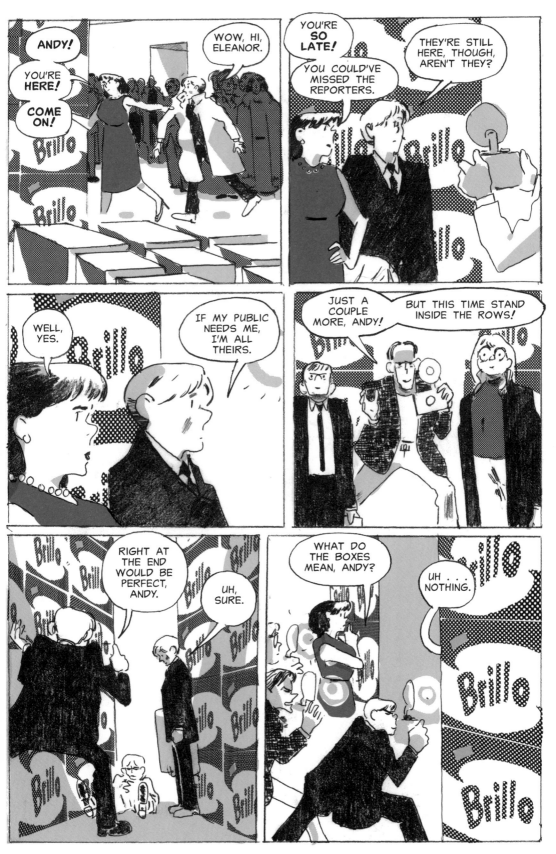

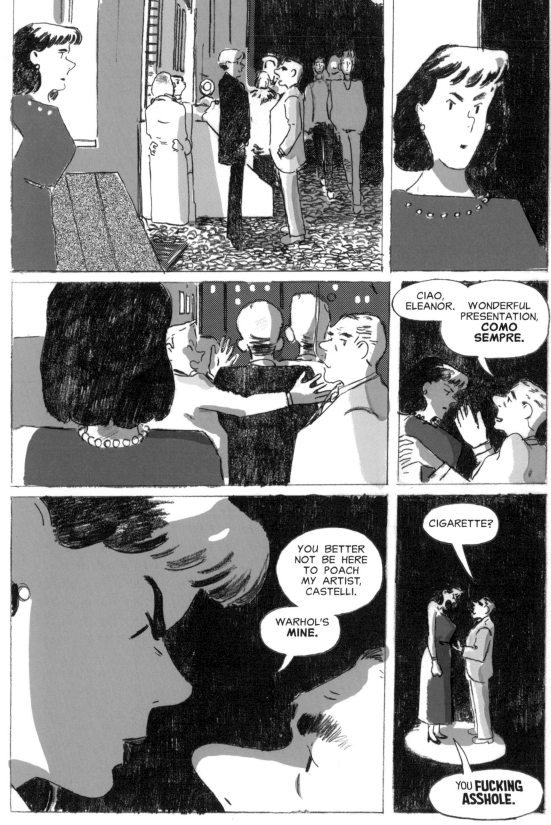

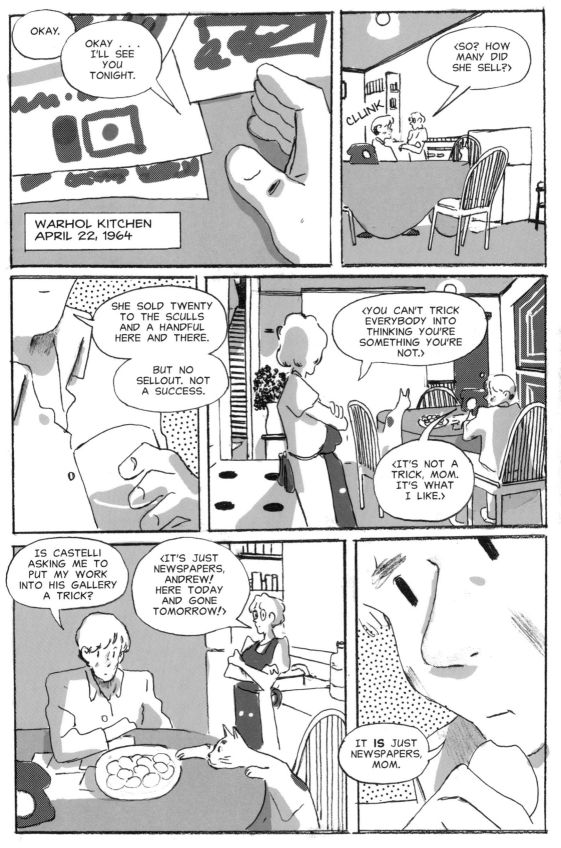

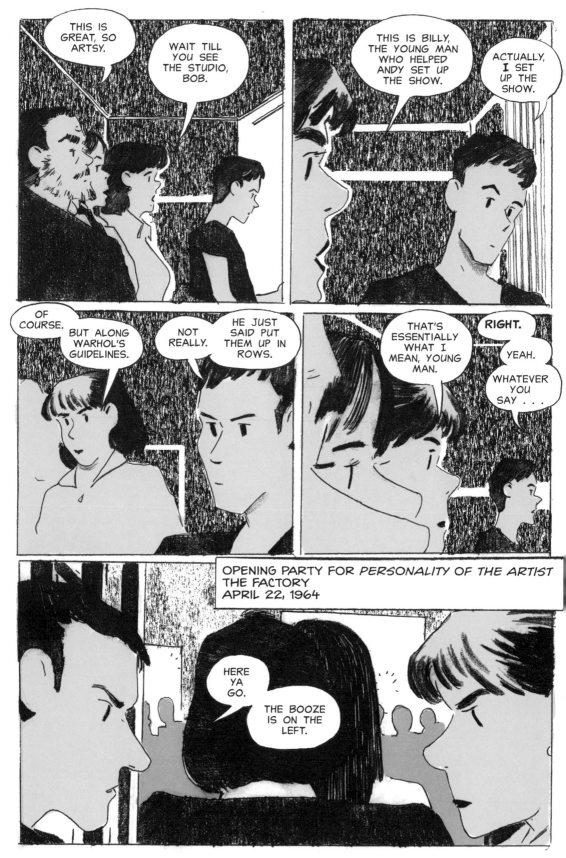

OPENING PARTY FOR *PERSONALITY OF THE ARTIST*
THE FACTORY
APRIL 22, 1964

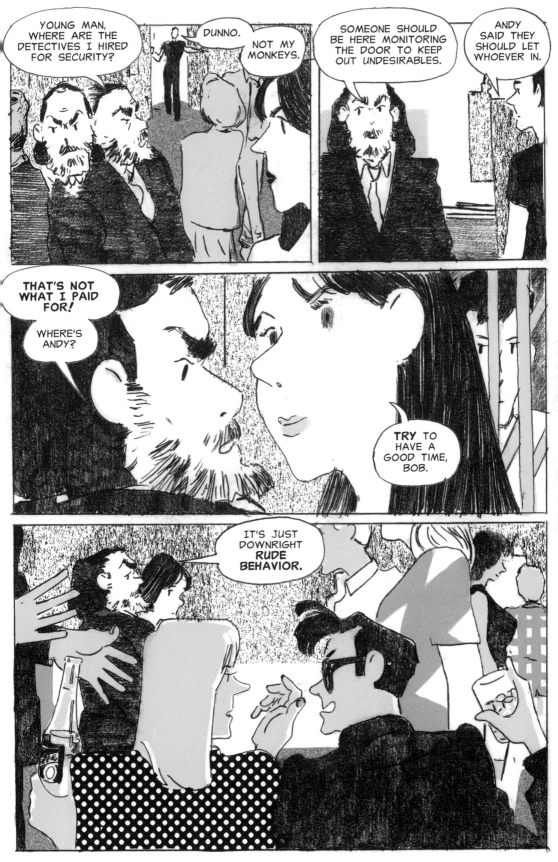

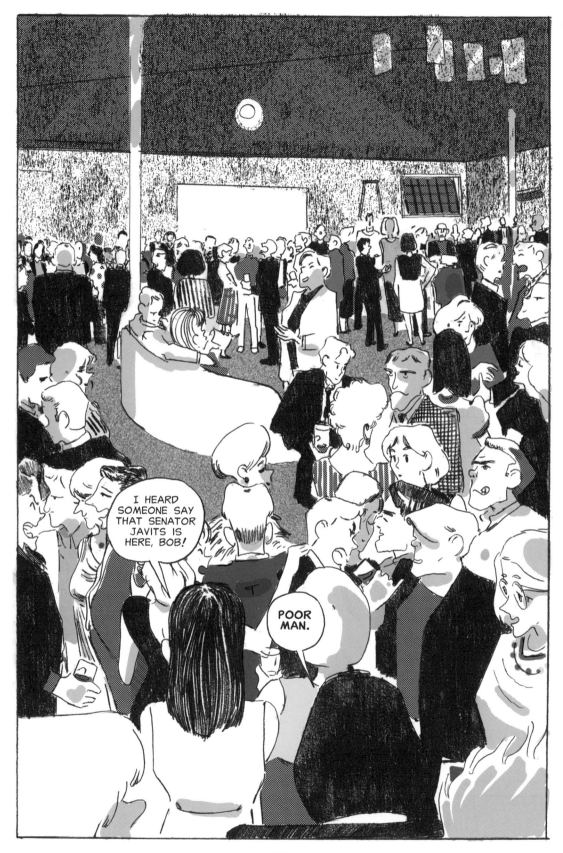

134

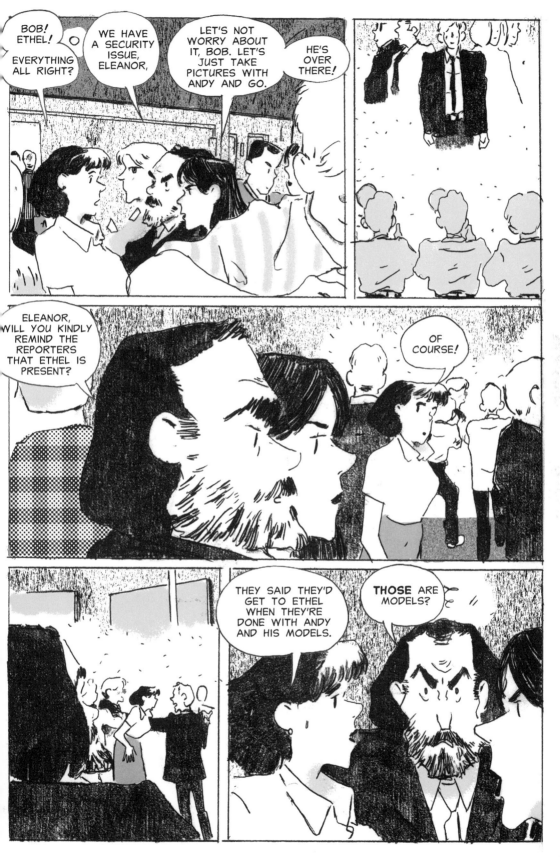

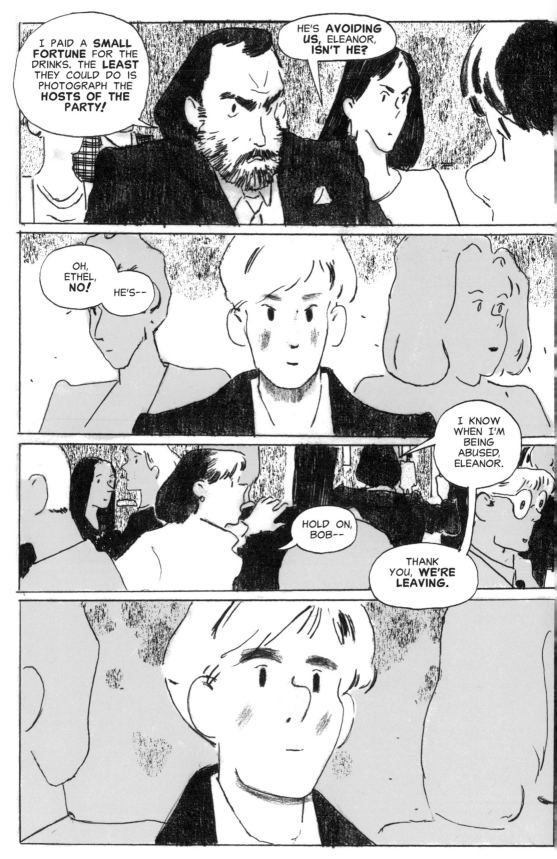

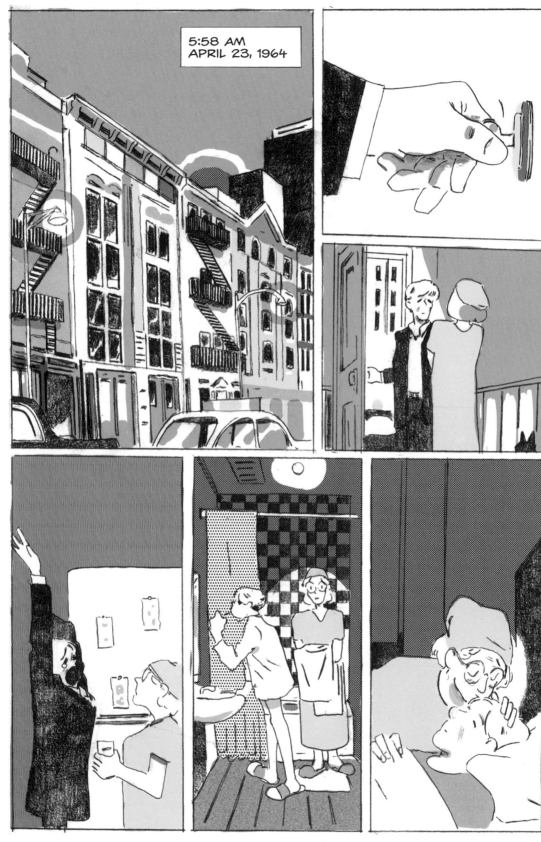

5:58 AM
APRIL 23, 1964

CHAPTER SIXTEEN

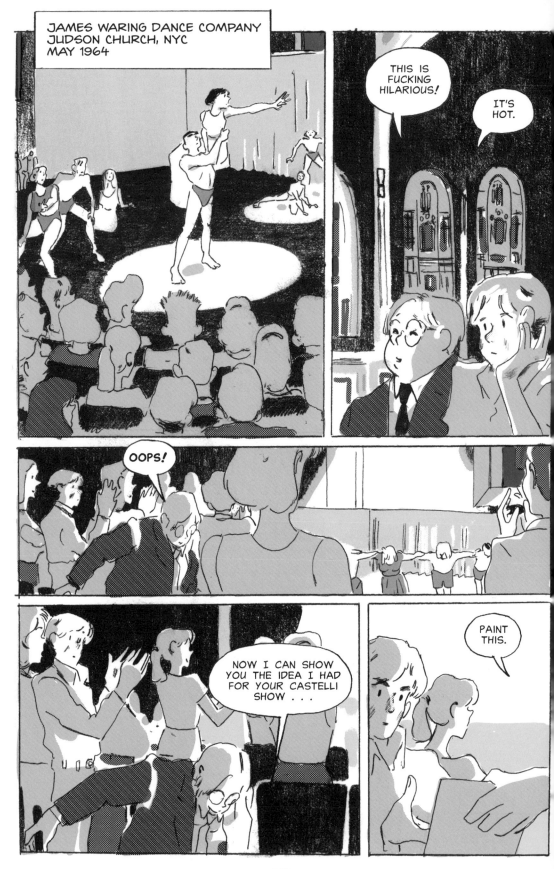

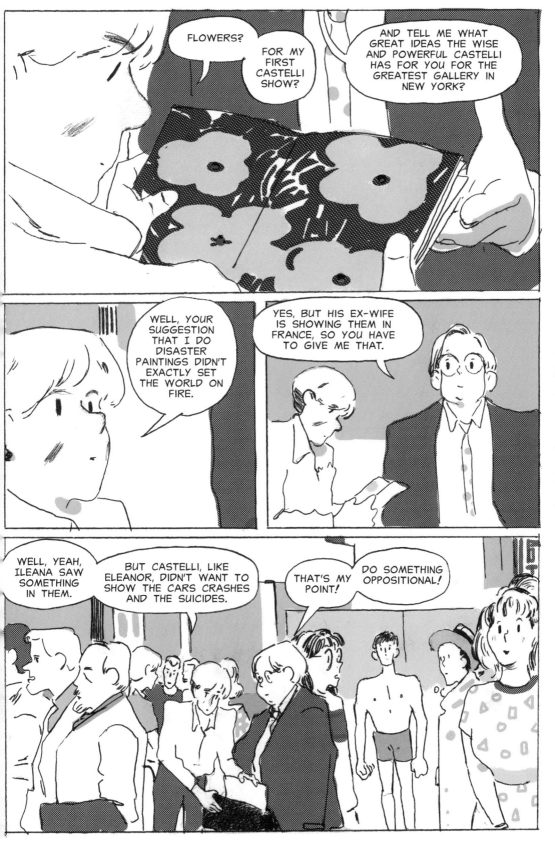

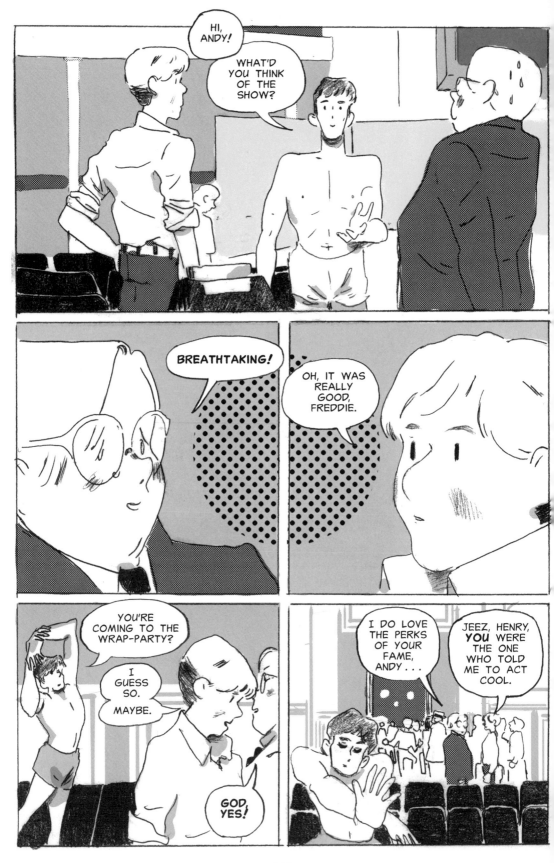

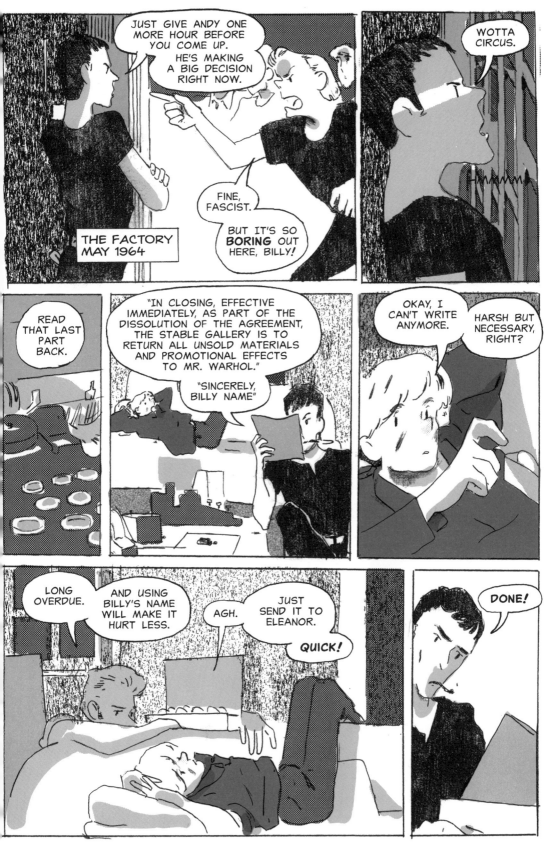

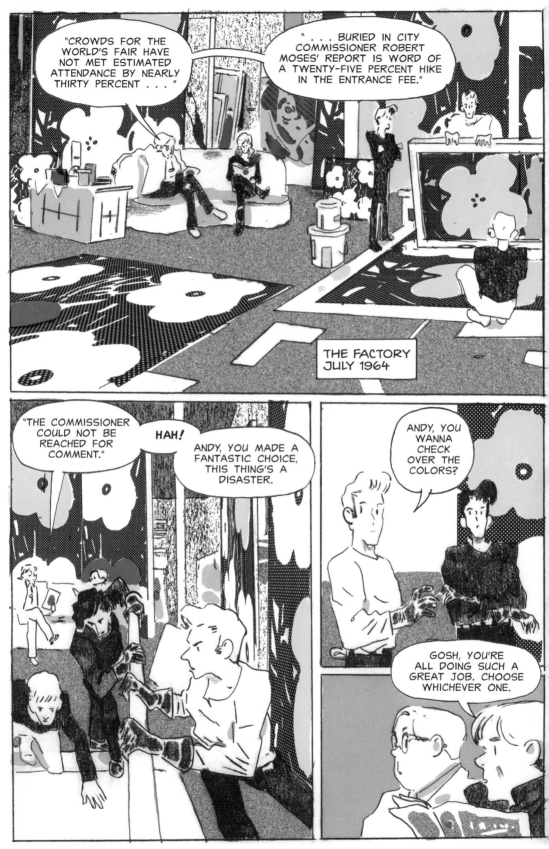

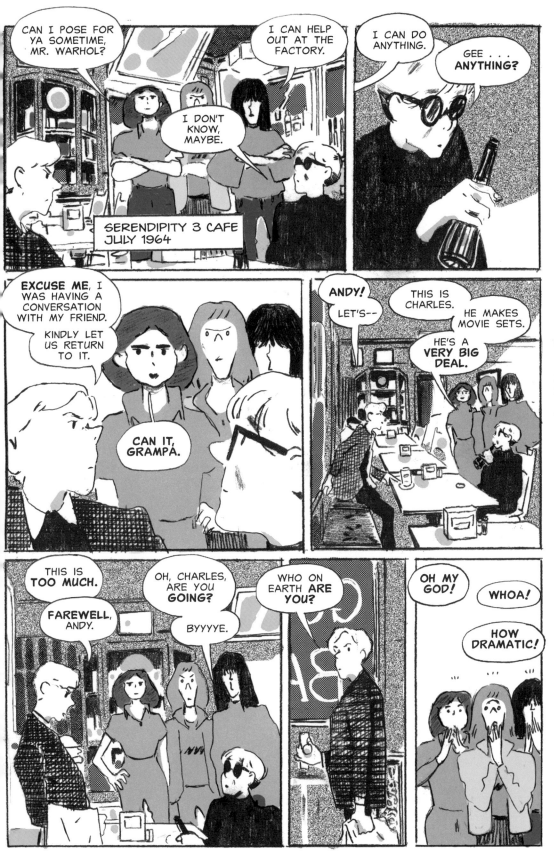

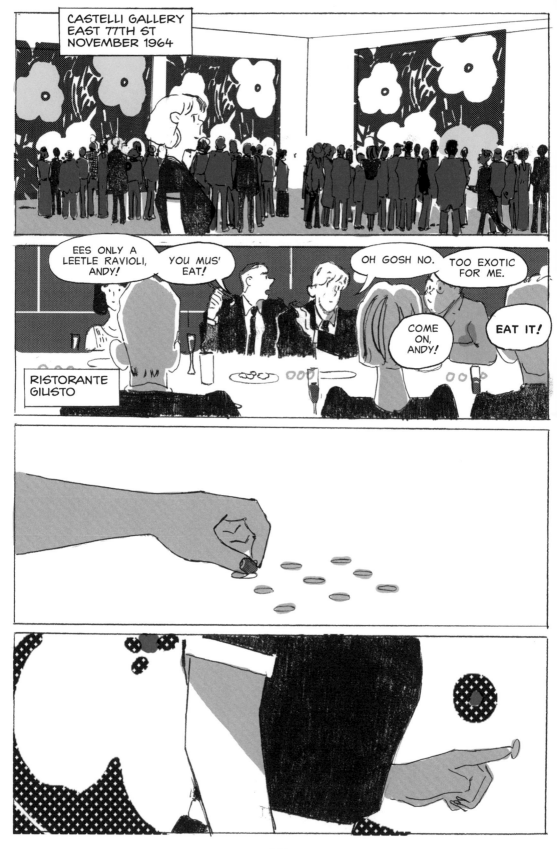

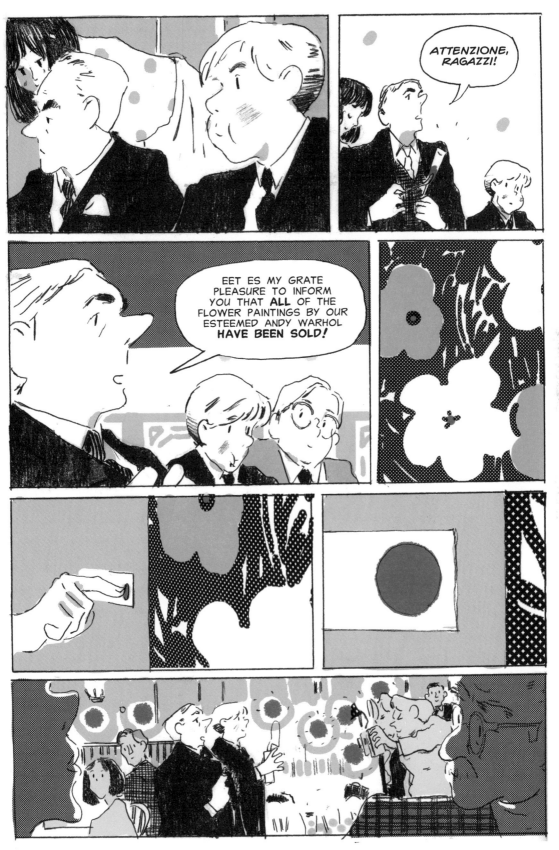

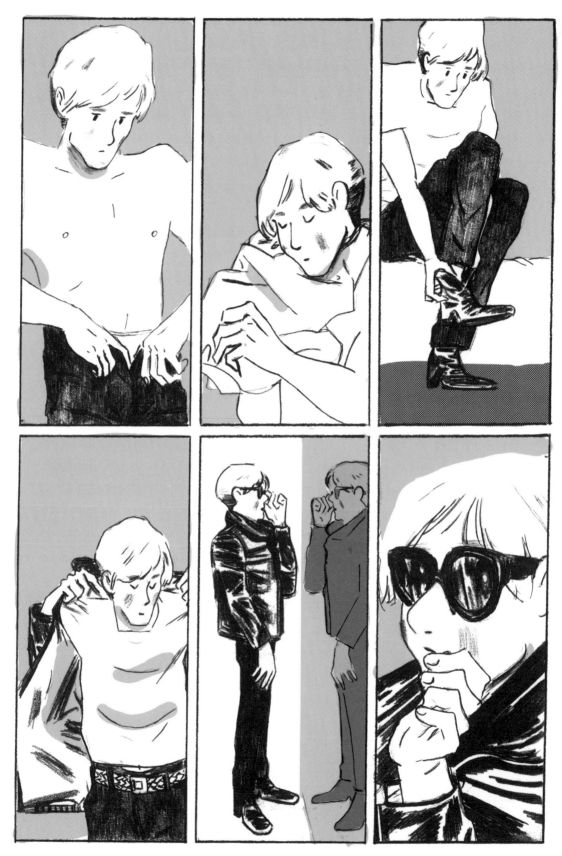

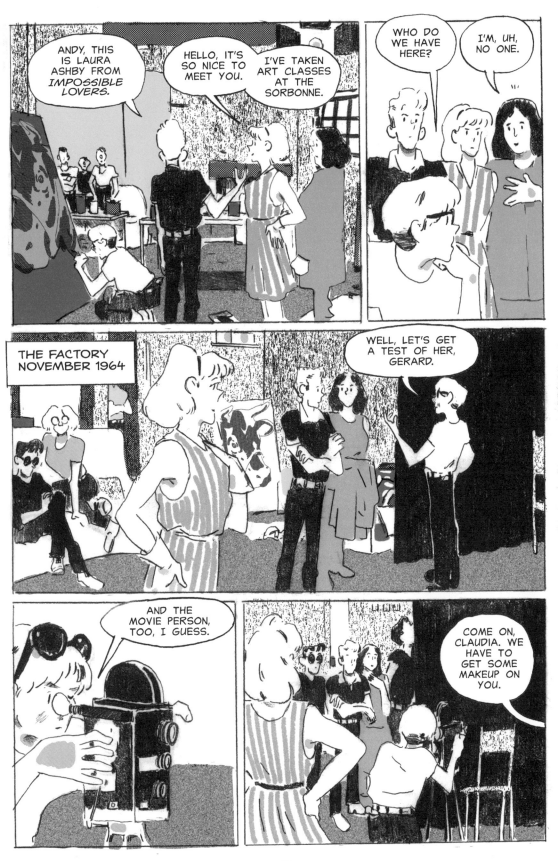

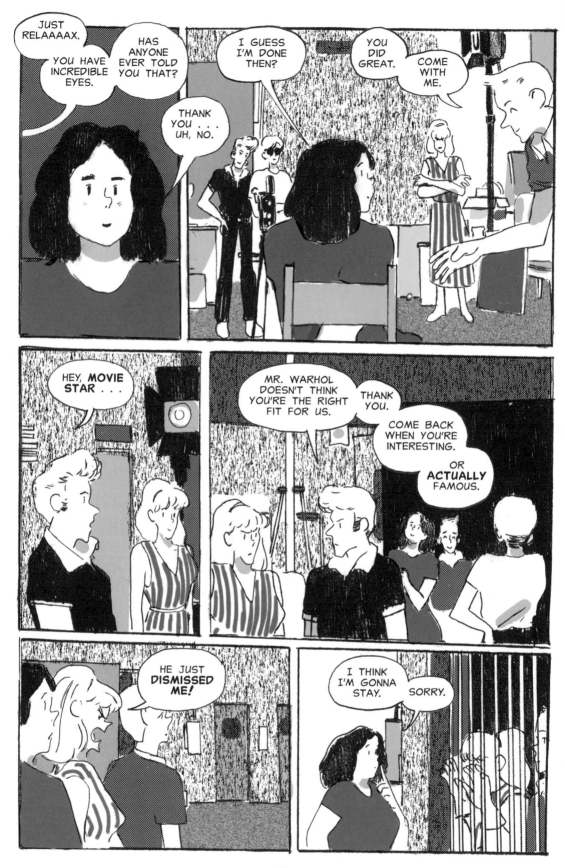

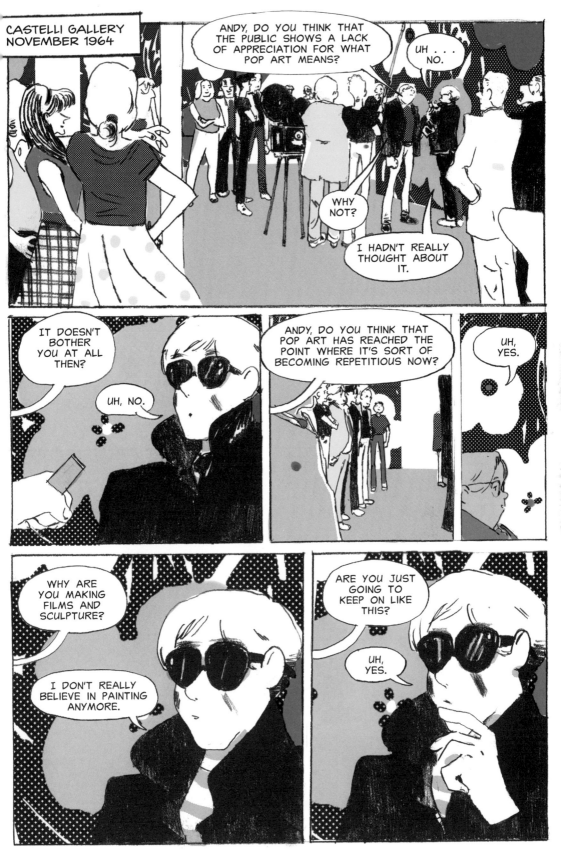

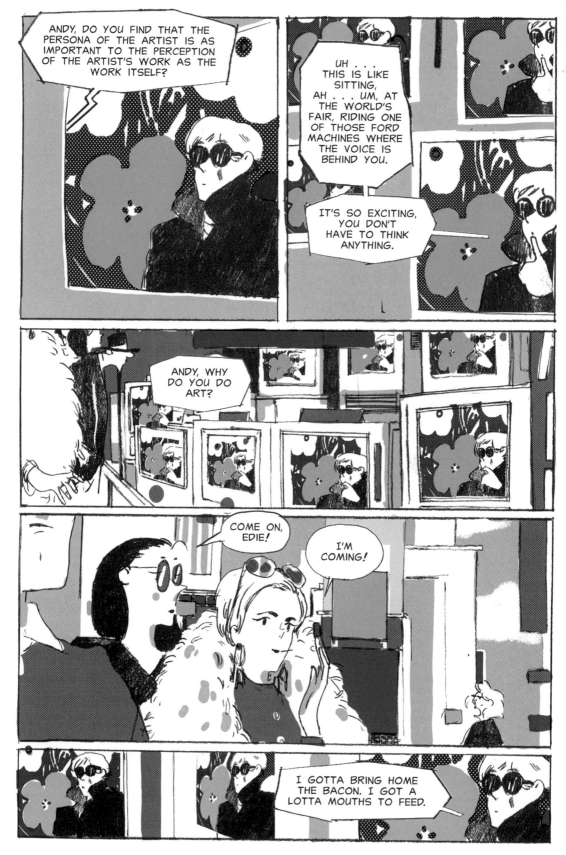

S●URCES

B●●KS

Bockris, Victor. *Warhol: The Biography*. Boston: Da Capo Press, 1997.

Cumming, Alan, and the Andy Warhol Foundation for the Visual Arts. *Andy Warhol: Men*. San Francisco: Chronicle Books, 2004.

Danto, Arthur C. *Andy Warhol*. Icons of America. New Haven, Conn.: Yale University Press, 2010.

Finkelstein, Nat, photographer. Introduction by David Dalton. Designed by Pentagram. *Andy Warhol: The Factory Years, 1964–67*. Edinburgh, U.K.: Canongate, 1999.

Goldsmith, Kenneth, ed. *I'll Be Your Mirror: The Selected Andy Warhol Interviews*. Introduction by Reva Wolf. Preface by Wayne Kostenbaum. Boston: Da Capo Press, 2004.

Koestenbaum, Wayne. *Andy Warhol*. Penguin Lives. New York: Viking, 2001.

Murphy, J. J. *The Black Hole of the Camera: The Films of Andy Warhol*. Berkeley: University of California Press, 2012.

Vartanian, Ivan, ed. *Andy Warhol: Drawings and Illustrations of the 1950s*. New York: D.A.P./Distributed Art Publishers, 2000.

Warhol, Andy. *a, A Novel*. New York: Grove Press, 1968.

———. *The Philosophy of Andy Warhol (From A to B & Back Again)*. New York: Harcourt Brace Jovanovich, 1975.

———. *The Andy Warhol Diaries*. Edited by Pat Hackett. New York: Warner Books, 1989.

———. *Andy Warhol Drawings*. San Francisco: Chronicle Books, 2012.

Warhola, James. *Uncle Andy's*. New York: G. P. Putnam's Sons Books for Young Readers, 2003.

WEBSITES

warhol.org

warhola.com

warholstars.org

AB●UT THE AUTH●R

NICK BERT●ZZI has written and drawn numerous comics, including *The Salon*, *Houdini: The Handcuff King*, *Lewis & Clark*, *Jerusalem*, and the *New York Times* bestseller *Shackleton: Antarctic Odyssey*. He lives in New York City with his wife and daughters.

AB●UT THE ILLUSTRAT●R

PIERCE HARGAN was born in Los Angeles and is a graduate of the School of Visual Arts in New York City. His work is featured in the acclaimed anthology *Schmuck*. This is his first graphic novel. He lives in Brooklyn.

Thank you to Kim and
the girls; family, friends, teachers
(especially Glenn Davis); all the librarians
ever; comic shops who give a rip; Pierce Hargan,
Joan Hilty, Wyeth Yates, Samantha Ulban, Bob Mecoy;
all at Abrams; and you for reading.
—N. B.

This book would not have been possible without the help
and support of Samantha Ulban and Wyeth Yates. Thanks
to Nick Bertozzi, Joan Hilty, Bob Mecoy, Pamela
Notarantonio and Charlie Kochman for believing
in the vision of a young cartoonist.
—P. H.

T● MY
THREE SISTERS
—N.B.

F●R
MY FAMILY
AND L●VED
●NES
—P.H.

Editor: Joan Hilty
Project Manager: Charles Kochman
Designer: Pamela Notarantonio
Managing Editor: James Armstrong
Production Manager: Kathy Lovisolo

Library of Congress Control Number: 2016931814

ISBN 978-1-4197-1875-5

Text copyright © 2016 Nick Bertozzi
Illustrations copyright © 2016 Pierce Hargan

Printed and bound in China
10 9 8 7 6 5 4 3 2 1

Abrams ComicArts books are available at special discounts when purchased in quantity
for premiums and promotions as well as fundraising or educational use. Special
editions can also be created to specification. For details, contact
specialsales@abramsbooks.com or the address below.

ABRAMS The Art of Books
115 West 18th Street, New York, NY 10011
abramsbooks.com